IMAGES
of America

MICHIGAN STATE FAIR

HAppy 90th
Birthday
Doris !

Love. Connie
Craig

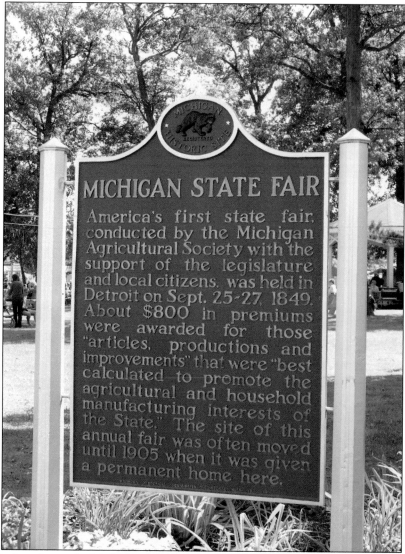

A historical marker at the Michigan State Fairgrounds tells the story of America's first state fair. Founded in 1849, the fair has run continuously for 160 years, with the exception of 1893 (the year of the World's Columbian Exposition in Chicago) and the World War II years (1942–1945, as well as 1946). After the 2009 Michigan State Fair, the streak ended. Due to the State of Michigan's budget crises, America's oldest state fair is no more.

ON THE COVER: Miss Michigan State Fair embodied the spirit, agriculture, and fun that the Michigan State Fair had to offer. Part of that fun was the annual Miss Michigan State Fair pageant. In 1958, at the age of 19, Lila Verslype of Harper Woods was crowned Miss Michigan State Fair. Among her many photographs is one in which she poses with a calf named Playboy, owned by Paul E. Tindall and Son of Oxford, Michigan. Today Lila Verslype Clause lives in St. Clair Shores and is the proud grandmother of three boys and three girls. (Courtesy of the Walter P. Reuther Library, Wayne State University.)

IMAGES
of America

MICHIGAN STATE FAIR

John Minnis and Lauren Beaver

ARCADIA
PUBLISHING

Published by Arcadia Publishing
Charleston, South Carolina

Printed in the United States of America

Library of Congress Control Number: 2009943869

For all general information contact Arcadia Publishing at:
Telephone 843-853-2070
Fax 843-853-0044
E-mail sales@arcadiapublishing.com
For customer service and orders:
Toll-Free 1-888-313-2665

Visit us on the Internet at www.arcadiapublishing.com

*It is with great joy that we dedicate this book to
Eugene Kondash—"Mr. State Fair"—and the Kondash family
for their lifetimes of dedication to the Michigan State Fair.*

CONTENTS

ACKNOWLEDGMENTS

We would like to thank the many people who took time out of their lives to help make this book possible.

First we would like to thank the Michigan State Fair 2009 general manager Robert Porter and able assistant Rosemary Peralta for opening their archives (and conference room) to us. This book would never have gotten off the ground without their openness and willingness to help. Many of the Michigan State Fair photographs originated from the State Archives of Michigan, a valuable resource offered by the State of Michigan.

It seems that in Michigan, and particularly Detroit, any historical book would not be possible without the assistance of the Burton Historical Collection of the Detroit Public Library and the Walter P. Reuther Library at Wayne State University. Ashley Koebel and Mark Bowden at the Burton Historical Collection were terrific, friendly, and timely in meeting our requests and answering our questions. Likewise, Elizabeth Clemens at the Walter P. Reuther Library was indispensable and went above and beyond in helping locate difficult-but-necessary photographs.

Special appreciation goes to Ruth Van Stee at the Grand Rapids Public Library. Her thoughtful input led us to avoid what would have been an embarrassing mistake.

We are also grateful to those individuals who made their photographs available to us, including *Teen News* publisher and music promoter Bob Harris, 1958 Miss Michigan State Fair Lila Verslype Clause, Robert Cummings, Kyle Arnoldi Jolley, Roger Meiners, and Kathy Jickling Matuszak. We would be remiss if we did not thank the photographers who were willing to let us use their photographs, including Jim Bonkowski, Natalie Zebula, and Don Bishop.

Special thanks also goes to former Michigan State Fair general manager John Hertel, who took time out of an over-booked schedule to share his experiences; and Harold "Hap" Tucker and his fellow car enthusiasts at the Model T Ford Club of America forum, who helped identify some of the vintage automobiles.

We would like to thank our editor at Arcadia Publishing, Anna Wilson, whose patience, advice, and clarifications kept our first book up to Arcadia Publishing's high standards.

Lastly, author John Minnis would like to thank his coauthor, Lauren Beaver, and his wife, Terry Minnis, for their patience and long suffering. Love and thanks also go to Corey McGregor for his patience and shuttle services. We would also like to thank Terry Minnis for her excellent and thorough proofreading skills. Any errors missed are the fault of the typist, not the proofreader or editors.

INTRODUCTION

It is hard to imagine all the lives the Michigan State Fair touched in its 160-year history. Not only did millions of Michigan residents attend the fairs over the years for amusement and edification, but also the exhibitors, homemakers, handcrafters, farmers, 4-Hers, and youth livestock clubs. Even urban gardeners found a venue at the Michigan State Fair to show off their produce and compete for ribbons and cash prizes.

For some people, like Eugene Kondash ("Mr. State Fair") and his mother, Catherine, the state fair was their lives. Both mother and son spent every year at the fair. Catherine moved into a home her father built directly across the railroad tracks from the Michigan State Fair when she 12. Her son was also raised in the house, and he joined his mother in all the state fair activities, particularly in the Community Arts Building. The Kondashes had fair workers to their home for dinner. Catherine Kondash said that even when she died, they would carry her to the fair, and her son fulfilled the promise. After his mother died in 1992, Eugene took her ashes with him on the next fair's opening day.

It is also difficult to imagine just how huge the Michigan State Fair was. Some early fairs took up a vast track of land between Cass Avenue and Third Street on what is now the Wayne State University campus. Readers are invited to check out the size of the 1894 Michigan State Fair building with its many turrets (page 15). The c. 1907 drawing of the fairgrounds (page 28) gives a great bird's-eye view of how big the fair once was. The modern fairs pale by comparison.

The Michigan State Fair bills itself as the "oldest" or "first" state fair, but the New York State Fair of 1838 actually earns the distinction as the first and oldest. Further, the New York fair ran continuously after 1841. Nevertheless, fans of the Michigan State Fair will likely never cede the point. The first attempt at an agricultural fair was slated for 1847 in Ann Arbor; however, that attempt turned out to be a failure. The first official Michigan State Fair was held in 1849 in Detroit in a field on the southwest corner of Woodward Avenue and Duffield Street, just north of Grand Circus Park. By all accounts, the first fair was a success. The fair moved to Ann Arbor in 1850, and in following years, it circulated throughout lower Michigan. Other cities to host the fair were Kalamazoo, Adrian, Jackson, Grand Rapids, East Saginaw, and Lansing. No fair was held in 1893 in deference to the World's Columbian Exposition that year in Chicago, and to its organizer, Thomas W. Palmer, namesake and benefactor of what would become Palmer Park and subdivision across Woodward Avenue from the future home of the Michigan State Fair.

What many proponents of keeping the Michigan State Fair in Detroit fail to realize is that Detroit was not the fair founders' first choice. Lansing, Michigan, was the original "permanent" home of the Michigan State Fair. However, the Michigan State Agricultural Society, the group that ran the fair, fell into debt and had to sell the property, which would in a few years be sold to Ransom Olds for an automobile manufacturing plant.

Detroit became the permanent home of the Michigan State Fair in 1905, when Hudson Department Store founder Joseph L. Hudson and three associates accumulated 135 acres at Woodward Avenue and the city's northern boundary, Eight Mile Road (then called Baseline Road). They sold the land to the Michigan State Agricultural Society for $1. The Michigan Building, originally constructed for the 1904 St. Louis World's Fair, was dismantled and reassembled on the new fairgrounds, serving as the first Administration Building and later as the Women's Building. Exhibit buildings and barns were quickly added, and within a few years, the Michigan State Fairgrounds had become quite a complex. Efficient city and statewide access was provided by Detroit's wonderful streetcar system and the Grand Truck Railroad. In 1921, the agricultural society deeded the property to the State of Michigan, and the following five years saw several impressive buildings added to the grounds. The Riding Coliseum and the Agricultural and Dairy Cattle Buildings are listed on the State and National Registers of Historic Places and are fine examples of the neoclassical revival architecture common to the world and state fairs of the time. (All three buildings were designed under the supervision of Lynn W. Fry of the State Building Department.) Federal largesse through the Works Progress Administration during the Depression added more buildings to the fairgrounds prior to World War II, during which no fairs were held.

After the war, little money was put into the fairgrounds. In 1962, a special commission called for a major financial and structural investment in the fairgrounds. The 1967 race riots further exacerbated the fair's woes, with many residents fleeing Detroit, never to return for any reason. By 1993, when John Hertel took over as general manager, the fairgrounds and buildings had fallen into serious disrepair. After decades of neglect, the urban fair seemed doomed. Attendance had already declined, and the sprawling suburbs made the Detroit Fairgrounds—and its agricultural attractiveness—too far removed from modern life. An attempt was made in the 1990s to provide the fairgrounds with a permanent source of revenue through auto racing. Even though auto racing of some sort had been held at the fair in past years—including two NASCAR races in 1951 and 1952—residents around the fair opposed the idea and successfully stalled the plans. Whether NASCAR or some other form of racing could have saved the fair will never be known.

With the recurring recession at the start of the 21st century and the decline and bankruptcy of the American auto industry, state coffers hemorrhaged red ink. On February 12, 2009, facing a $1.8 million budget deficit, Gov. Jennifer Granholm cut funding for future state fairs (after the 2009 fair). Then on October 31, 2009, Granholm vetoed a $7 million line item that would have added one more year to the Michigan State Fair. As of December 2009, the 160-year run of the Michigan State Fair had ended. The fate of the historical buildings, the "World's Largest Stove," and the statue of Seabiscuit—to name a few of the state fair's gems—is a great unknown. The state fair may reopen in future years elsewhere in lower Michigan—perhaps even in Lansing, the fair's first "permanent" home—but it will not be *the* Michigan State Fair.

One

THE NOMADIC FAIR

The first Michigan State Fair was held in Detroit in 1849. In this painting by Frederick E. Cohen, J. C. Holmes, secretary of the Michigan State Agricultural Society, which established the fair, reads the winners from a premium list worth $800. (Note the fairgrounds in the doorway.) Cohen emigrated from England to Detroit in 1837 and found employment painting panels for Great Lakes passenger vessels. Pres. Zachary Taylor is shown in the banner at top. (Courtesy of the Burton Historical Collection, Detroit Public Library.)

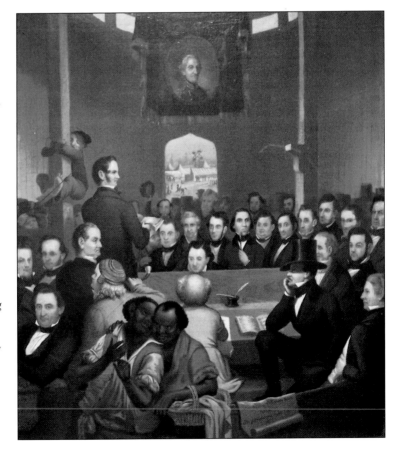

While Michigan boasts the "first" state fair, New York actually held the nation's first state fair in 1838. Some 15,000 attended the first Michigan State Fair, which was considerable since Detroit's population at the time was only 20,000. (Times were tough and many had fled the state to be part of the California Gold Rush.) The second annual Michigan State Fair was held in Ann Arbor, and the fair alternated among host cities throughout southern Michigan—Kalamazoo, Adrian, Jackson, Grand Rapids, East Saginaw, and Lansing—before settling permanently in Detroit in 1905. Murals depicting the first Michigan State Fair and other fair highlights were painted on the east facade of the fairgrounds Coliseum in 2005 by a group called the Letterheads. (Photograph by John Minnis.)

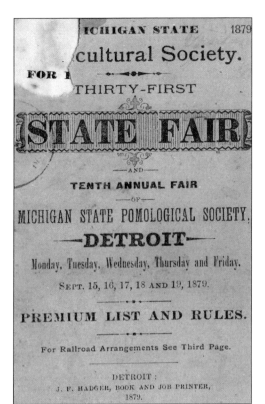

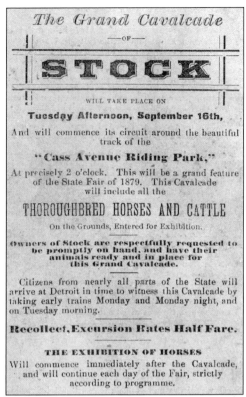

ICHIGAN STATE 1879
cultural Society.

FOR
THIRTY-FIRST

STATE FAIR

—AND—

TENTH ANNUAL FAIR
—OF—
MICHIGAN STATE POMOLOGICAL SOCIETY,
—DETROIT—
Monday, Tuesday, Wednesday, Thursday and Friday.

SEPT. 15, 16, 17, 18 AND 19, 1879.

PREMIUM LIST AND RULES.

For Railroad Arrangements See Third Page.

DETROIT :
J. F. HADGER, BOOK AND JOB PRINTER,
1879.

The Grand Cavalcade
—OF—

STOCK

WILL TAKE PLACE ON
Tuesday Afternoon, September 16th,
And will commence its circuit around the beautiful
track of the
"Cass Avenue Riding Park,"
At precisely 2 o'clock. This will be a grand feature
of the State Fair of 1879. This Cavalcade
will include all the

THOROUGHBRED HORSES AND CATTLE

On the Grounds, Entered for Exhibition.

Owners of Stock are respectfully requested to
be promptly on hand, and have their
animals ready and in place for
this Grand Cavalcade.

Citizens from nearly all parts of the State will
arrive at Detroit in time to witness this Cavalcade by
taking early trains Monday and Monday night, and
on Tuesday morning.

Recollect, Excursion Rates Half Fare.

THE EXHIBITION OF HORSES
Will commence immediately after the Cavalcade,
and will continue each day of the Fair, strictly
according to programme.

Among the earliest artifacts of the Michigan State Fair is this premium list and rules from the 31st fair held in Detroit in 1879. It was also the 10th annual fair sponsored by the Michigan State Pomological Society, formed in 1870 to promote Michigan's burgeoning orchard and berry industries. The back cover of the premium list promotes "The Grand Cavalcade," a livestock parade around the "Cass Avenue Riding Park." (Both courtesy of Robert Cummings.)

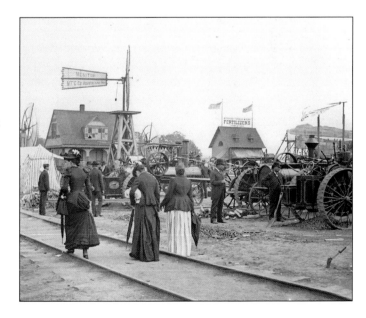

While the men examine tractors at the 1889 Detroit International Exhibition, the women stroll along the railroad tracks leading to the windmill, locomotive, and exhibition buildings in the background. A glass negative of this image gives the location as Michigan State Fair. (Courtesy of the Burton Historical Collection, Detroit Public Library.)

11

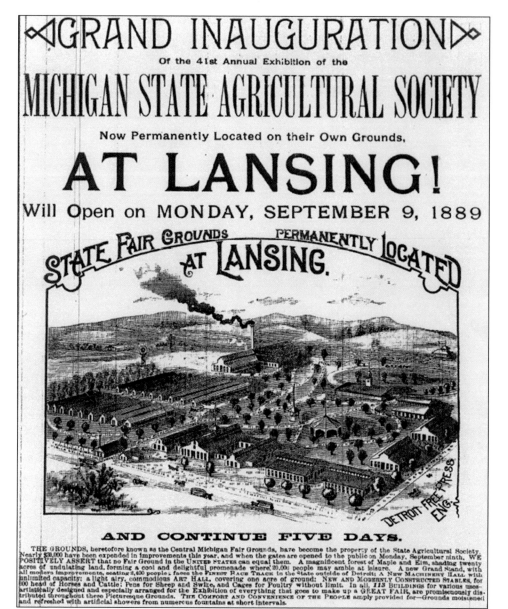

◁GRAND INAUGURATION▷

Of the 41st Annual Exhibition of the

MICHIGAN STATE AGRICULTURAL SOCIETY

Now Permanently Located on their Own Grounds,

AT LANSING!

Will Open on MONDAY, SEPTEMBER 9, 1889

STATE FAIR GROUNDS PERMANENTLY LOCATED AT LANSING.

DETROIT FREE PRESS ENG.

AND CONTINUE FIVE DAYS.

THE GROUNDS, heretofore known as the Central Michigan Fair Grounds, have become the property of the State Agricultural Society. Nearly $30,000 have been expended in improvements this year, and when the gates are opened to the public on Monday, September ninth, WE POSITIVELY ASSERT that no Fair Ground in the UNITED STATES can equal them. A magnificent forest of Maple and Elm, shading twenty acres of undulating land, forming a cool and delightful promenade where 20,000 people may amble at leisure. A new Grand Stand, with all modern improvements, seating 2,400 people, faces the FINEST RACE TRACK in the State outside of Detroit; A NEW MACHINERY HALL with unlimited capacity; a light, airy, commodious ART HALL, covering one acre of ground; NEW AND MODERNLY CONSTRUCTED STABLES, for 600 head of Horses and Cattle; Pens for Sheep and Swine, and Cages for Poultry without limit. In all, 113 BUILDINGS for various uses—artistically designed and especially arranged for the Exhibition of everything that goes to make up a GREAT FAIR, are promiscuously distributed throughout these Picturesque Grounds. THE COMFORT AND CONVENIENCE OF THE PEOPLE amply provided for—Grounds moistened and refreshed with artificial showers from numerous fountains at short intervals.

In the August 26, 1889, issue of the *State Republican* (forerunner of the *Lansing State Journal*), the Michigan State Agricultural Society advertised the "State Fair Grounds Permanently Located at Lansing." In preparation for the 1889 fair, $30,000 was spent on improvements to the former Central Michigan Fair Grounds, including fountains, a new grandstand with unlimited capacity, new stables, an art hall, and a 20-acre forest of "Maple and Elm" housing a "delightful promenade where 20,000 people may amble at leisure." Despite these improvements—or because of them—Lansing would not remain the permanent home of the Michigan State Fair. The buildings and improvements had proved too costly for upkeep, causing the agricultural society to turn the grounds over to its creditors. Due to continued financial strain and the World's Columbian Exposition in Chicago, no fair took place in 1893. Detroit, however, did hold a successful state fair in 1894. In 1901, Ransom E. Olds would build an assembly plant on the site, where the last Oldsmobile rolled off the line on April 29, 2004. (Courtesy of the *Lansing State Journal*.)

Thomas W. Palmer, who made his fortune in lumbering, served in the Michigan and U.S. Senates and as U.S. minister to Spain. In 1890, Palmer returned to the United States to become president of a national commission charged with organizing the 1893 World's Columbian Exposition in Chicago. Also called the Chicago World's Fair, the Columbian Exposition was designed to celebrate the 400th anniversary of Columbus's arrival in the New World. As president of the national commission, Palmer pushed for an "educational" amusement area in an unused strip of land called the "Midway Plaisance." While the emphasis on education gave way to more lucrative sideshow attractions, the "Midway" was a huge success, and the term "midway" came into popular use to describe amusement areas at all fairs, including at the Michigan State Fair. In 1897, Palmer donated to the City of Detroit 140 acres of farmland across Woodward Avenue from what would one day be the home of the Michigan State Fair. The land would later become Detroit's Palmer Park and a subdivision by the same name. (Courtesy of the Burton Historical Collection, Detroit Public Library.)

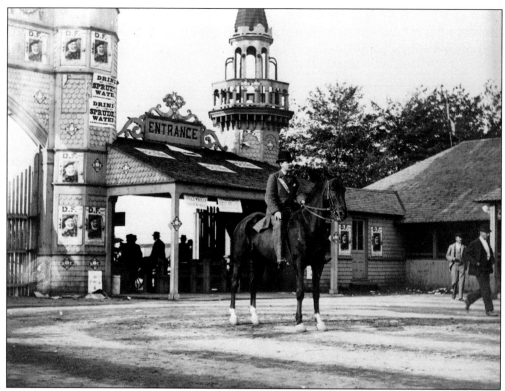

A sentry on horseback greets visitors to the 1894 Michigan State Fair held in Detroit. The 1894 fair was a success, due in part to Detroit businessman and statesman Thomas W. Palmer, who headed the national commission that organized the 1893 World's Columbian Exposition in Chicago. He was the first to introduce the profitable "midway" to American fairgrounds. The advertising for "D. F. Cigars" promotes one cigar for 10¢ or three for 25¢. (Courtesy of the Walter P. Reuther Library, Wayne State University.)

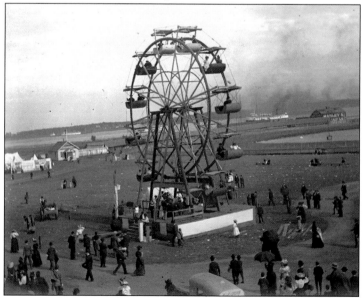

The appearance of the Ferris wheel at the 1894 Michigan State Fair marked a new beginning in the dynamics of the midway. George Washington Gale Ferris Jr. designed the first Ferris wheel, which made its debut at the 1893 World's Columbian Exposition in Chicago, just one year before its inclusion at the Michigan State Fair. (Courtesy of the Burton Historical Collection, Detroit Public Library.)

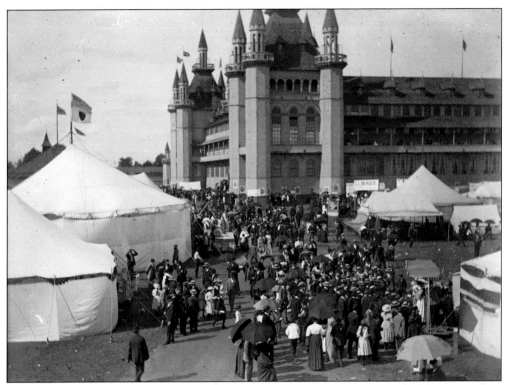

The 1894 Michigan State Fair featured a rather impressive, turreted main building, as well as rows of vendors in tents offering goods and innovative farm machinery. The Japanese flag, above, marks the location of a Japanese dancing show. Of course, also included among the fair vendors were fortune tellers and exotic, foreign performers. In 1894, throngs of fairgoers flocked to the fairgrounds by train, boat, and carriage, only to be fascinated by the not always authentic "foreign" performances. (Both courtesy of the Burton Historical Collection, Detroit Public Library.)

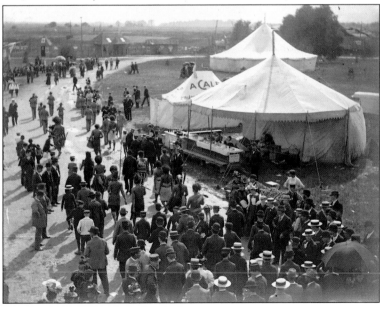

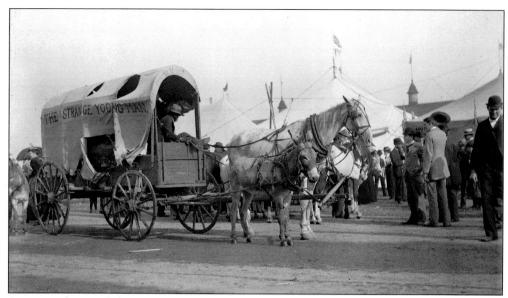

Strange and unusual characters were not so unusual at the 1894 Michigan State Fair in Detroit. One attraction (above) had no problem calling himself the "The Strange Young Man." Check out the horse and donkey pulling the wagon; talk about juxtaposition. Another attraction (below)—or it could be the same one—proclaims, "From Mexico to Jerusalem." Attaching the name of a foreign country to an exhibit was a guaranteed revenue booster. No matter how unlikely the authenticity of the exhibits, fairgoers, dressed in their Sunday best, flocked to them. (Both courtesy of the Burton Historical Collection, Detroit Public Library.)

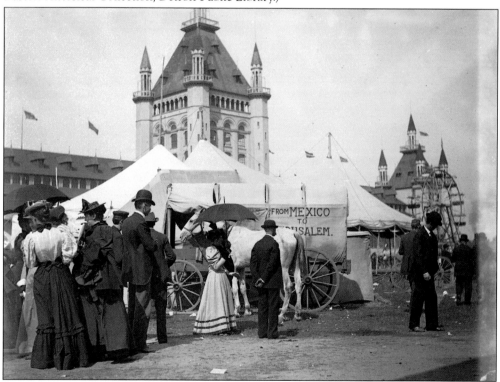

Agricultural equipment was important fare at the 1894 Michigan State Fair, including windmills and potato diggers. The potato digger was invented by Isaac W. Hoover, who obtained a patent for them in 1885. Hoover potato diggers revolutionized the gathering of potatoes from the field. They easily separated earth and weeds from the potatoes and could be used on hilly as well as level ground, allowing a man with a team of horses to dig as much as 500 bushels a day. Soon a very profitable company formed, and in 1916 the extensive plant covered 4 acres, producing 5,000 machines per year that were shipped to every industrialized country in the world. In 1926, the company merged with John Deere Plow Company, and I. W. Hoover retired from the business. (Both courtesy of the Burton Historical Collection, Detroit Public Library.)

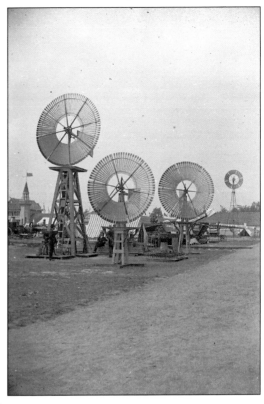

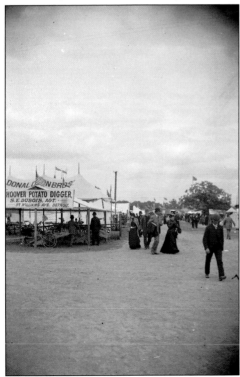

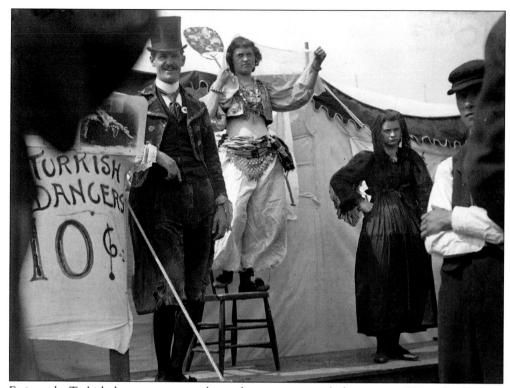

Fatima, the Turkish dancer, was a popular performer among male fairgoers in 1894 and helped the Michigan State Fair out of its financial lows. Fatima's clothing, which would have been considered inappropriate at the time, was excused on the grounds that she was an "authentic" cultural dancer. The name "Fatima" was a generic name for foreign exotic dancers of the time. The Women's Society at the Michigan State Fair vehemently opposed the performance of such dancers, specifically Fatima. (Courtesy of the Burton Historical Collection, Detroit Public Library.)

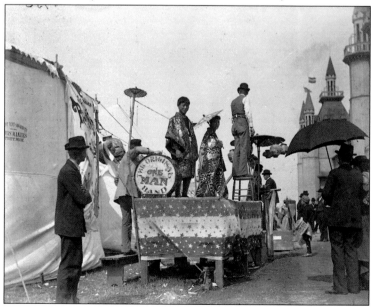

Japanese performers attracted large crowds as they performed in traditional Japanese clothing. The authenticity is questionable, but curious fairgoers of the time believed the exhibits. The money fairgoers spent to see these performances made them more inclined to take the performances at face value. (Courtesy of the Burton Historical Collection, Detroit Public Library.)

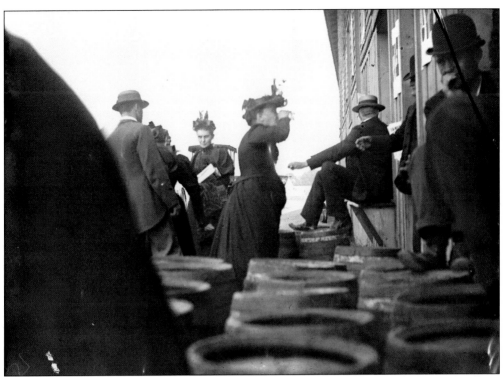

Fairgoers gather around kegs of alcohol at the 1894 Michigan State Fair. Although alcohol consumption had decreased from its early-19th-century all-time high per capita, it was still an enormous part of American economy and culture. The Prohibition movement began in the early 1840s, headed by religious groups. This movement led to the Progressive Era, which lasted from 1890 to 1920 and spread hostility toward saloons and the political influence they had. (Courtesy of the Burton Historical Collection, Detroit Public Library.)

Buck Taylor was a major attraction at the 1894 Michigan State Fair in Detroit. Taylor played Gen. George Armstrong Custer in William F. Cody's reenactment of the Battle of Little Bighorn in the Buffalo Bill Wild West Show. Taylor, known as "The First Cowboy King," performed with Annie Oakley, Wild Bill Hickok, Will Rogers, and Tom Mix. (Courtesy of the Burton Historical Collection, Detroit Public Library.)

Above, a circle of young girls snacks at the Michigan State Fairgrounds in Detroit in 1894. Chances are they were not drinking the Sprudel Water from Mount Clemens, Michigan, which was advertised as "An Effervescing Aperient and Diuretic, Useful in Kidney Disease." Mount Clemens mineral water was marketed across the country for both drinking and as a medicine. The water had mild laxative properties and was touted as a cure for all manner of digestive upsets and chronic diseases. Below, men on a Michigan Stove Company wagon give handouts to the crowding children. The Michigan Stove Company, creators of the "World's Largest Stove," was one of the several stove manufacturing companies in Michigan. (Both courtesy of the Burton Historical Collection, Detroit Public Library.)

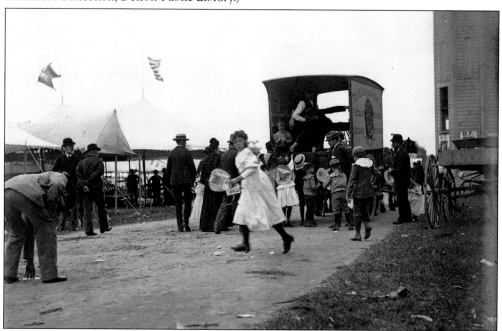

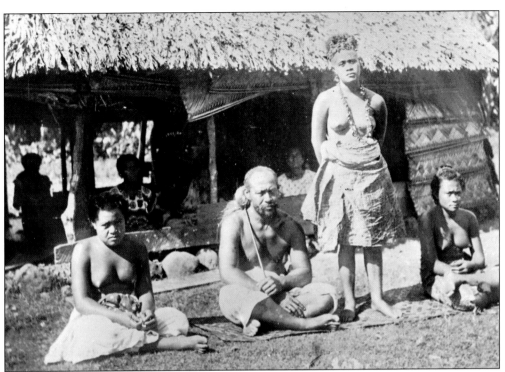

South Sea Islanders, most likely conscripted Polynesians on the eve of the annex of Hawaii by the United States in 1898, were one of the many ethnic groups included in exhibits at the 1894 Michigan State Fair. They were paraded around the fairgrounds as fascinating subjects to the fairgoers. The 19th century was a time of cultural curiosity, and the South Sea Islanders, in their native clothing and sitting in front of their traditional homes, attracted many oglers. A downside to the exhibition of other cultures at state fairs was the exploitation of them and their customs. (Both photographs by Jex Bardwell, courtesy of the Burton Historical Collection, Detroit Public Library.)

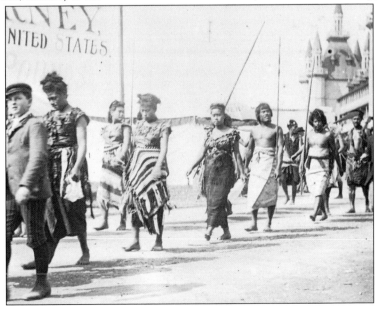

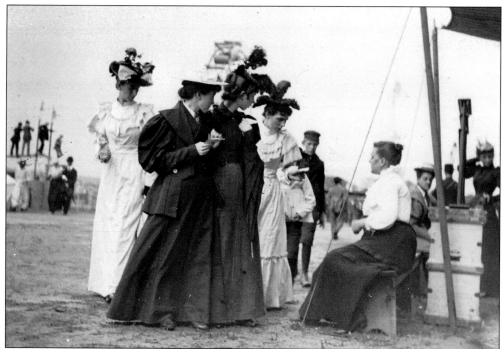

Women at the 1894 Michigan State Fair seem quite attracted to the fortune teller. The popularity of fortune telling, magic shows, and the paranormal grew immensely in the 19th century. However, this phenomenon dates back to the 18th century, when English colonists partook in "van shows." These shows were named for the wooden carts that carried fortune tellers, magicians, freaks, menageries, and dancers to and from villages during market fairs. In 19th-century America, many communities had ordinances forbidding fortune telling. Either that was not the case in Detroit in 1894 or officials decided to look the other way as long as such activity was limited to the midway. (Both photographs by Jex Bardwell, courtesy of the Burton Historical Collection, Detroit Public Library.)

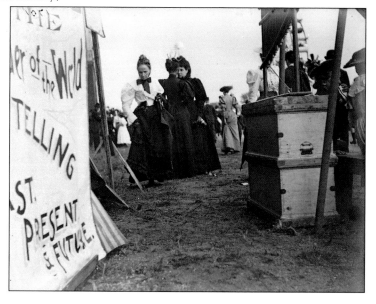

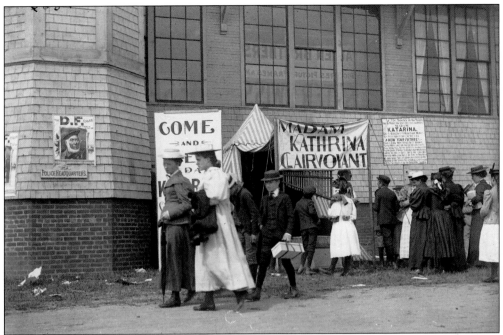

Clairvoyants like Madam Katarina were very popular, and the 1894 Michigan State Fair was no exception. Beckoning fairgoers with promises of their futures foretold, a sign to the right of the exhibit entrance reads, "Is the Wonder of the World in telling the past present and future Madam Katarina. Noted daughter of Rhineland Makes her first appearance in the city. KNOW YOUR FUTURE!—from a lady who stands first among those who can read and predict the future, this lady had been invited to many courts throughout Europe to display her wonderful talent in this respect. She is the same who foretold with exactness the fate of Napoleon II and gave specifications in regard to the downfall of the Empire. Her renown as a clairvoyant is only encompassed by the limit of the universe." Fairgoers below flood from doubtless another clairvoyant presentation. (Both courtesy of the Burton Historical Collection, Detroit Public Library.)

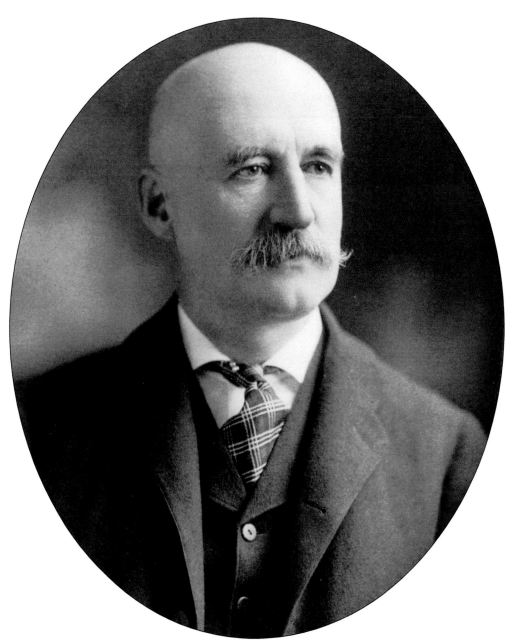

Joseph L. Hudson, founder of the famous Detroit department store bearing his name (now Macy's), is credited with providing the permanent home of the Michigan State Fair. In 1905, Hudson and three associates formed the State Fair Land Company and accumulated 135 acres to be used as the permanent home of the Michigan State Fair at Eight Mile and Woodward Avenue in Detroit. Hudson had no desire to run the fair, and the land was sold for $1 to the Michigan Agricultural Society. Hudson was born October 17, 1846, in Newcastle upon Tyne, England, and immigrated to Michigan with his family when he was a boy. Besides founding the famous department store, Hudson helped fund the Hudson Motor Car Company and was involved in many Detroit business and civic interests. Hudson never married. He died on July 5, 1912, and left no personal papers. (Courtesy of the Burton Historical Collection, Detroit Public Library.)

Two

AT HOME IN DETROIT

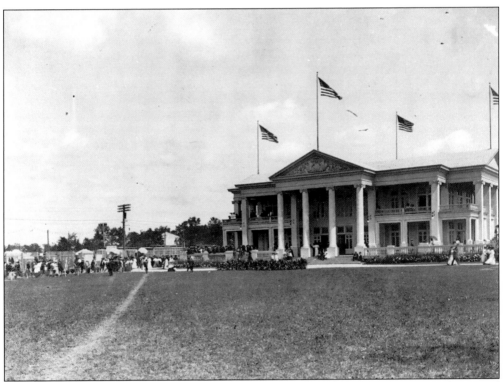

The elegant Michigan Building welcomed visitors to the 1906 Michigan State Fair, the second year the fair was held at its permanent Detroit location. Built in 1904 for the World's Fair in St. Louis, the building was brought to the Michigan State Fairgrounds in 1905, where it would serve many purposes and have many names over the years, including the Administration Building and Women's Building. It is unknown when the building was removed. (State Archives of Michigan, courtesy of the Michigan State Fair.)

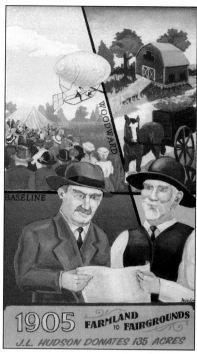

In 1905, Detroit department store magnate Joseph L. Hudson donated 135 acres of land he and three associates had accumulated at Baseline Road (Eight Mile Road) and Woodward Avenue in Detroit to the Michigan State Agricultural Society for use as the permanent home of the Michigan State Fair. In 1921, the agricultural society deeded the land to the State of Michigan to "provide for the future holding of the annual fair under its direction." A mural depicting J. L. Hudson donating the land to the Michigan State Agricultural Society was painted in 2005 by a group called the Letterheads. (Photograph by John Minnis.)

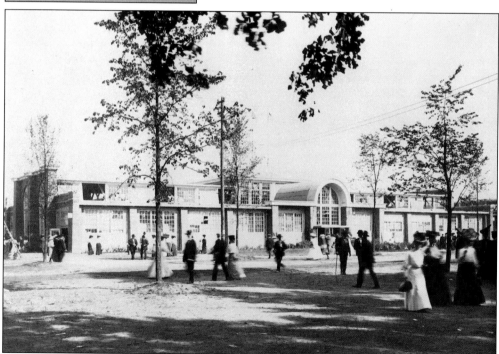

Although this picture was taken at the 1909 Michigan State Fair, the main exhibit hall must have been built several years prior, as it appeared on a 1907 bird's-eye view drawing of the fairgrounds. The building saw heavy use for nearly 40 years before it was destroyed by fire in 1942. The cause was a cigarette butt tossed by a careless teenage smoker. (State Archives of Michigan, courtesy of the Michigan State Fair.)

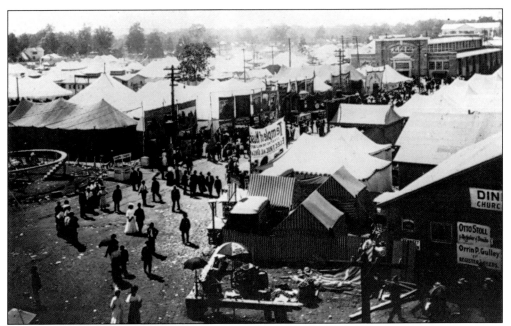

These early midway photographs can be dated to 1906, when Otto Stoll opposed Orrin P. Gulley for register of deeds. Gulley was seeking his third term as register of deeds when he defeated Stoll. Previously Gulley had served as school inspector, highway commissioner, justice of the peace, supervisor, and county poor commissioner. Stoll would win election two years later and serve for six consecutive terms. He had previously served in the Michigan House of Representatives, the Wayne County Jury Commission, and as deputy county clerk. Though the fair had only been at the Detroit location for two years, note the number of permanent buildings already constructed among the multitude of vendors' tents. (Both State Archives of Michigan, courtesy of the Michigan State Fair.)

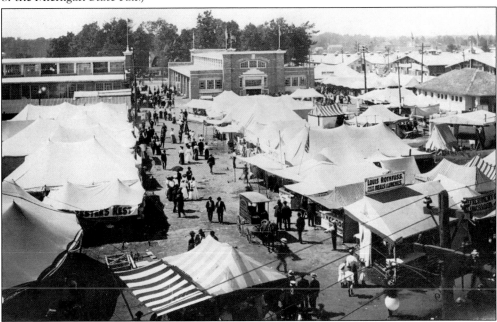

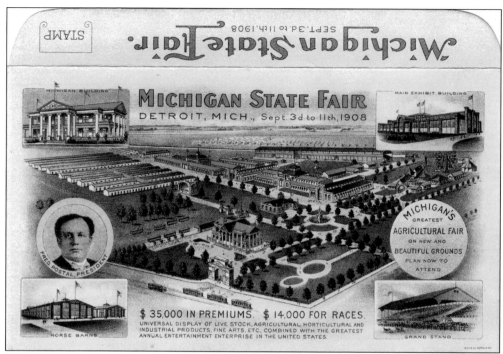

This 1908 envelope/postcard depicts a detailed drawing of the Michigan State Fairgrounds. Note the insets of the buildings, barns, and grandstand as well as the streetcars running along Woodward Avenue. Barely visible beyond the racetrack is the Grand Truck Railroad, which is still in existence today. Agricultural society president Fred Postal owned Hotel Griswold and was once co-owner of the Washington Senators baseball team. (Courtesy of Robert Cummings.)

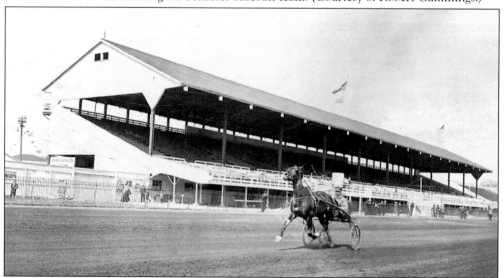

The 5,000-seat grandstand was among one of the earliest structures built at the Michigan State Fair. During its near century lifetime, the grandstand hosted harness racing—as shown in this 1910 postcard—as well as thoroughbreds, early auto racing, NASCAR, Wild West shows, top-name entertainers and, in the late 1960s and early 1970s, drug-laden rock concerts. The grandstand was declared unsafe in 1971 and torn down 30 years later. (Courtesy of Robert Cummings.)

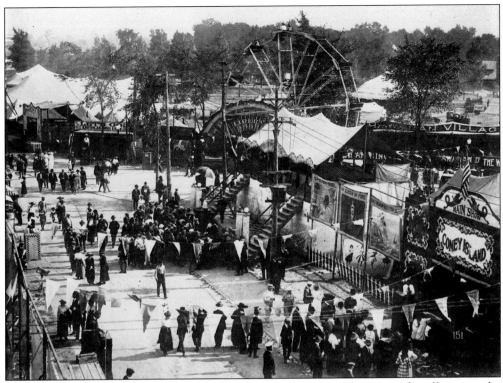

"Spider Girl," "The Queen of Fire," and "Half Woman-Half Fish, Alive" were the offerings at the Main Show Coney Island at an early-1900s Michigan State Fair. Coney Island on the Atlantic Ocean outside of New York City was the largest amusement park in the nation at the time and featured the best carnival rides and sideshows. No wonder state fairs copied its name and offerings. (Courtesy of the Burton Historical Society, Detroit Public Library.)

Cattle judging was an important event at the Michigan State Fair in the early 1900s. While farmers in bib overalls position their prize cattle, city women in white dresses and men in suits wander safely outside the fenced-in show area. (State Archives of Michigan, courtesy of the Michigan State Fair.)

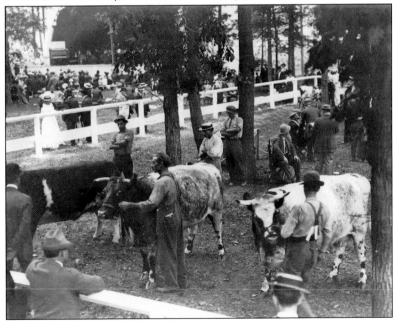

29

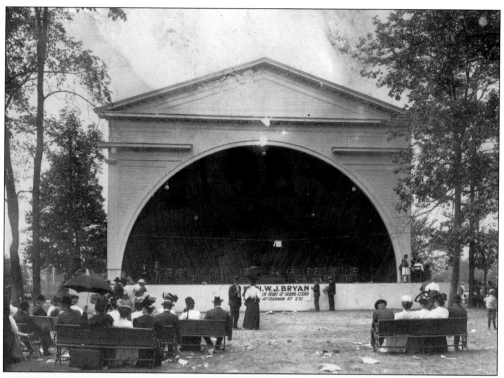

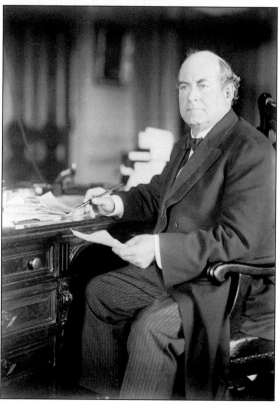

Michigan State Fair organizers hang a banner in preparation for one of the great orators of the day, William Jennings Bryan. At the time of his 1906 speech in Detroit, Bryan was the most popular among the Chautauqua speakers. Considered a liberal Democrat, Bryan favored an eight-hour work day and believed religion was the basis of moral values. In 1925, Bryan would gain attention as a participant in the Scopes trial, where the teaching of evolution was being prosecuted. Bryan, pictured at left around 1913, had already lost a presidential bid in 1900 and would again lose in 1908. In 1913, he would join Pres. Woodrow Wilson's cabinet as secretary of state. (Above, State Archives of Michigan, courtesy of the Michigan State Fair; at left, courtesy of the Library of Congress.)

William Howard Taft became the 27th president of the United States by defeating William Jennings Bryan in 1908. Speaking to crowds at the 1911 Michigan State Fair, Taft most likely rallied against "the trusts" and "robber barons" of the day. Taft is also known for establishing the postal savings bank and the parcel post system. A progressive Republican, he favored the 16th and 17th Amendments, which allowed for the federal income tax and the direct election of U.S. senators. Taft's portrait, seen at right, was painted by Theodore Molkenboer in 1912. (At right, courtesy of the Library of Congress; below, courtesy of the Walter P. Reuther Library, Wayne State University.)

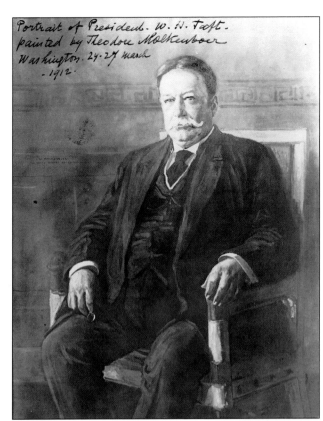

Portrait of President. W. H. Taft. painted by Theodore Molkenboer Washington. 24·27 march - 1912.

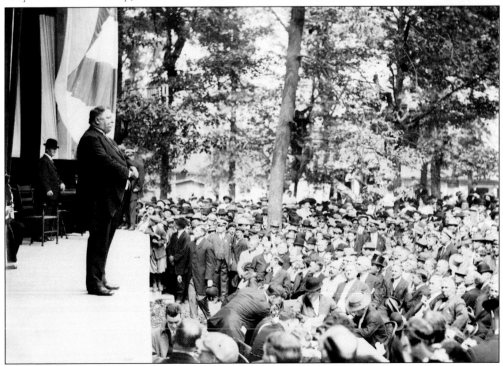

Is it a five-legged calf? A snake handler? The fat woman? Who knows, sideshows—or freak shows—were common since at least the 18th century. Fair managers tried to keep out the more seamy, repulsive acts, but they were lucrative. As early as the 1870s, sideshow operators were paying $150 apiece for a midway location, according to the *American State Fair* by Derek Nelson. Further, lots of people enjoyed the shows—including this crowd of mostly men at an early-20th-centruy Michigan State Fair, while the women weren't quite so sure. (Both courtesy of the Walter P. Reuther Library, Wayne State University.)

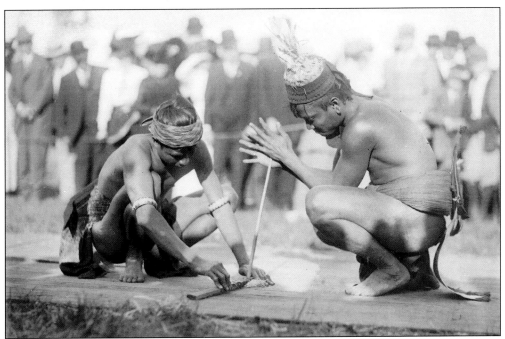

Among the casualties of the Spanish-American War were the so-called headhunters of the Philippines, the Moro people. Moro (Moor) is a derogatory name given by Spanish colonial conquerors over Islamic Filipinos. Following victory over the Spanish in 1898, American and Philippine officials used the 1904 World's Fair to acquaint visitors with their products, industries, art, peoples, education, and customs. Secretary of War William H. Taft, who had been governor of the Philippine Islands, had the initial idea to present the exhibit. Some 47 acres were set aside at the St. Louis exhibition for the Philippine Reservation. There Moros and other Filipinos built huts and demonstrated living and hunting skills. The Moros then apparently traveled the fair circuit. At the Michigan State Fair, they are shown making fire and performing a war dance. (Both *Detroit News*, courtesy of the Walter P. Reuther Library, Wayne State University.)

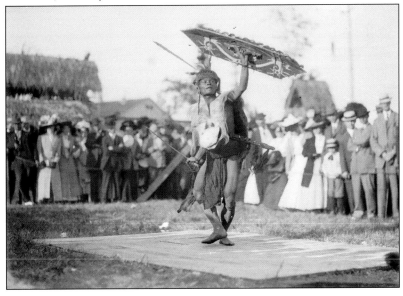

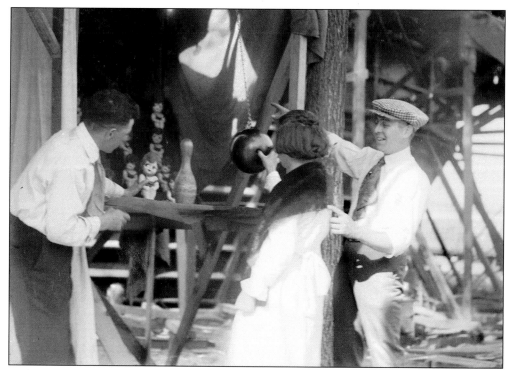

Midway games were popular among fairgoers. At an early-20th-century Michigan State Fair, contestants in this game appear to be trying to knock down bowling pins with a bowling ball attached to string. Notice the kewpie doll below riding on the bowling ball and the dolls aligned along the back as prizes. Kewpie dolls were all the rage in the early 1900s. They were based on comic strip illustrations by Rose O'Neill that appeared in *Ladies' Home Journal* in 1909. The game operator, or "carny" (though the label is not thought to have been coined until the 1930s), was a lot better dressed than his counterpart today. (Both courtesy of the Walter P. Reuther Library, Wayne State University.)

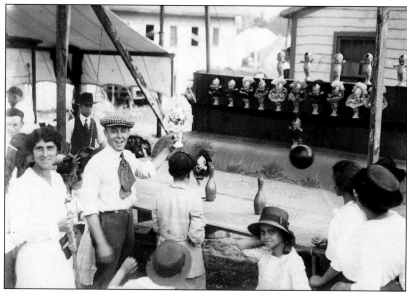

Something new started appearing outside the gates at the Michigan State Fair in the first decade of the 1900s—the automobile. Car manufacturing exploded at the turn of the century, not just in Detroit but around the world. Besides Ford and Oldsmobile, Detroit had myriad other carmakers, including the R-C-H (Robert Craig Hupp) Corporation. Above, parked behind the Vernor's Ginger Ale stand (another legendary Detroit company) is believed to be a 1913 R-C-H "Hupmobile." According to the company advertising at the time, R-C-H planned to produce 3,000 Hupmobiles in 1913 at a list price of "$900 f.o.b. Detroit." Notice, too, the Lohrman Seed Company umbrellas; Lohrman was also a longtime Detroit business. Of course, Henry Ford did make probably the largest impact on the automobile scene with the introduction of the Model T in 1908. During the Model T's 20-year run, 15 million "Tin Lizzies" were produced. In the c. 1909 photograph below, the first and seventh cars from the right are thought to be Model Ts, as are many more. (Both State Archives of Michigan, courtesy of the Michigan State Fair.)

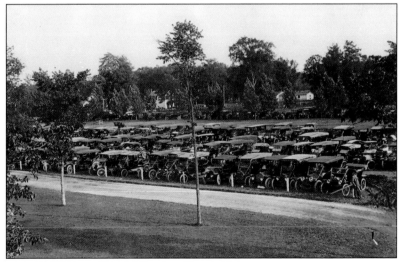

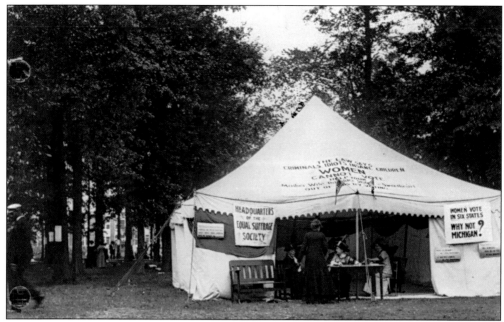

Women's suffrage (the right to vote) was a hot topic at the Michigan State Fair of 1912, a presidential election year. The Equal Suffrage Society set up a tent at the 1912 fair, and suffragists came out in droves to hear what their sisters had to say. Michigan voters considered women's suffrage amendments on both the 1912 and 1913 ballots; both were defeated. Liquor interests were accused of sabotaging the effort, since many Prohibition supporters were women. Women finally won the right to vote in Michigan in 1918. National women's suffrage would follow in 1920 with ratification of the 19th Amendment. (Both State Archives of Michigan, courtesy of the Michigan State Fair.)

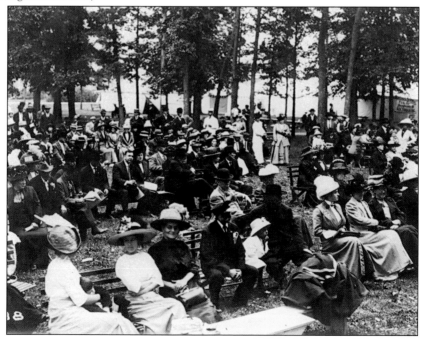

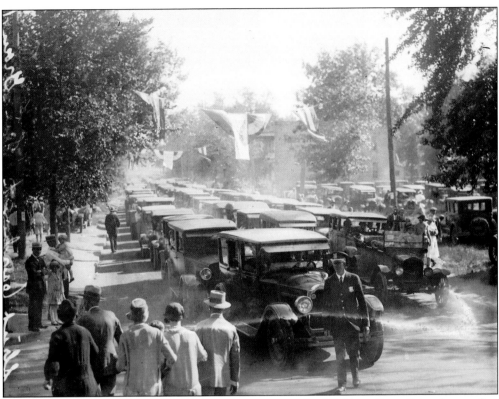

By the 1920s, traffic jams were a common occurrence at the Michigan State Fair, where police officers now found themselves directing traffic and crossing pedestrians. According to Harold "Hap" Tucker of the Model T Ford Club of America, leading the pack is believed to be a 1923–1925 Packard, and to its left is a 1919 or 1920 Model T, depending on whether it has an electric starter. (Courtesy of the Walter P. Reuther Library, Wayne State University.)

Following Charles Lindbergh's successful 1927 transatlantic flight in his custom single-engine, single-seat monoplane, the *Spirit of St. Louis*, the "Spirit" gripped the nation, to which this "Spirit of Michigan" produce display at the Michigan State Fair attests. (Courtesy of the Walter P. Reuther Library, Wayne State University.)

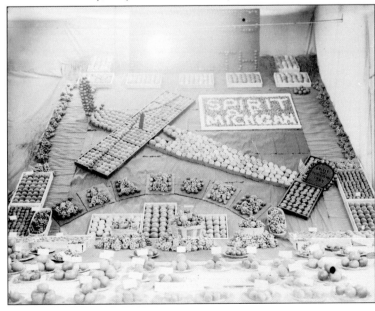

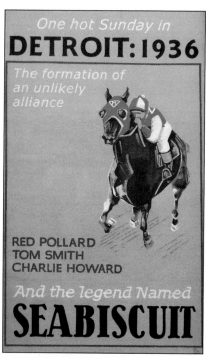

One hot Sunday in
DETROIT:1936

The formation of an unlikely alliance

RED POLLARD
TOM SMITH
CHARLIE HOWARD

And the legend Named
SEABISCUIT

Seabiscuit's winning years under new owner Charles Howard, trainer Tom Smith, and jockey Red Pollard began on August 22, 1936, at the Michigan State Fairgrounds. While Seabiscuit, son of Hard Tack and grandson of Man O' War, made an unimpressive showing that day, he returned on September 7, 1936, and before a crowd of 28,000 people at the Detroit Fairgrounds won his first major stakes race, the Governor's Handicap. Seabiscuit repeated the feat again at the fairgrounds on September 26, 1936, winning the Hendrie Handicap. The mural depicting Seabiscuit's first major win was painted in 2005 by a group called the Letterheads. (Photograph by John Minnis.)

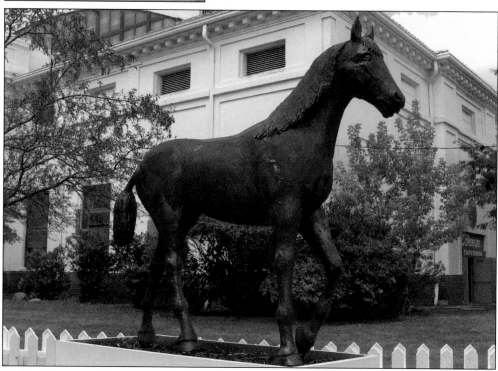

Seabiscuit returned to the Michigan State Fairgrounds on August 18, 2005, when his statue was unveiled by racing commissioner Christine White and sculptor Larry Halbert. Seabiscuit and a historical marker are located at the southeast corner of the Coliseum. (Photograph by Natalie Zebula.)

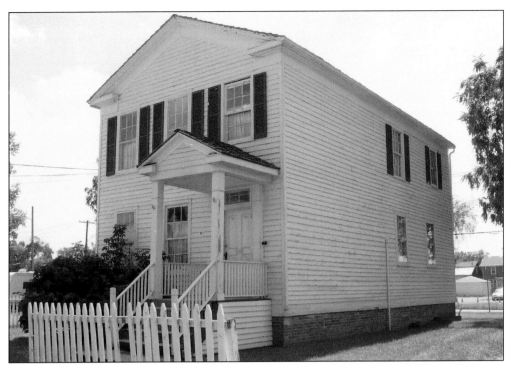

Built in 1835, the Grant House was the short-time home of Lt. (and later Gen.) Ulysses S. Grant. He resided in this house with his family for one year in 1849—coincidentally the first year of the Michigan State Fair. At the time, the house stood at 253 Fort Street, now 1389 Fort, between Russell and Rivard Streets, in Detroit. Grant rented the house for about $250 per year. Although the home was scheduled for demolition in 1936, the Michigan Mutual Liability Company purchased it and handed it over to the State of Michigan. That year the Grant House was moved to the Michigan State Fairgrounds, where it remains temporarily. (Photograph by John Minnis.)

The Grant House was open for exhibits and tours during earlier days of the fair. Stove exhibits were always popular at the Michigan State Fair, especially during the first half of the century when they were necessities of farm life. (Courtesy of the Michigan State Fair.)

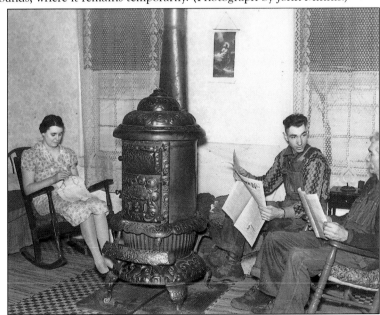

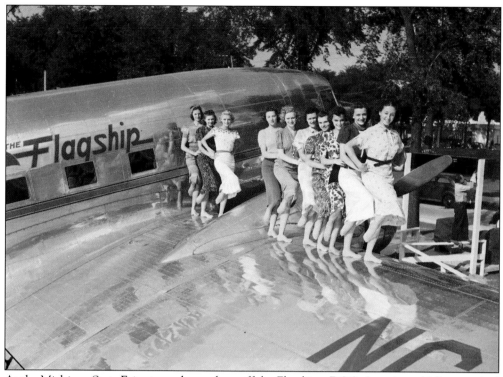

At the Michigan State Fair, stewardesses show off the *Flagship*, a DC-3. American Airlines worked with Donald Douglas to develop the DC-3, which they started flying in 1936. With the DC-3, American began calling its aircraft Flagships and established the Admirals Club for valued passengers. The DC-3 was one of the workhorses of World War II and set the standard for the fledgling commercial passenger industry. (*Detroit News*, courtesy of the Walter P. Reuther Library, Wayne State University.)

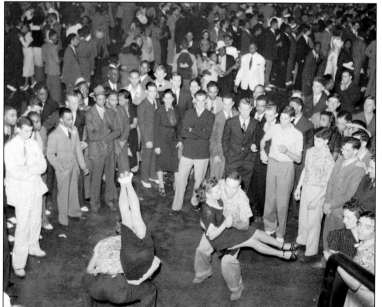

The Detroit News reported that "jitterbugs, hep-cats and alligators went wild under the spell of Benny Goodman's music" during a special swing session at the August 31, 1938, Michigan State Fair. (*Detroit News*, courtesy of the Walter P. Reuther Library, Wayne State University.)

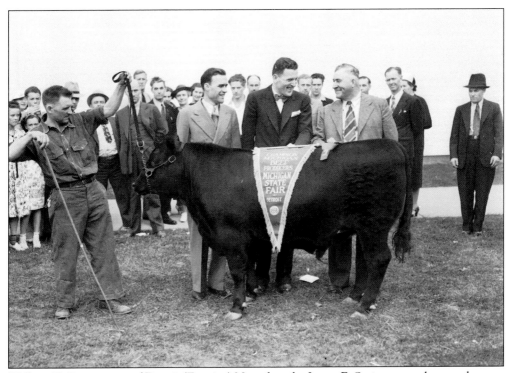

William E. Scripps, son of *Detroit (Evening) News* founder James E. Scripps, was the proud owner of the Grand Champion Steer, Laddie Boy of Wildwood, at the 1938 Michigan State Fair. From left to right are herdsman Price Brown, fair livestock director Elmer R. Haines, fair general manager Frank N. Isbey, and Scripps farm manager Sydney Smith. Laddie was the brother of the 1937 Grand Champion Steer, Black Mike, owned by Detroit Tigers manager Mickey Cochrane, who was also known as "Black Mike." (*Detroit News*, courtesy of the Walter P. Reuther Library, Wayne State University.)

Taking part in the Commercial Arts exhibits was DuPont, demonstrating its Tontine washable window shades. The George F. McDonald Company at 8108 Grand River Avenue, one of Tontine's "Authorized Dealers," is still in existence as McDonald Wholesale Distributors at 19536 West Davison in Detroit. Thomas McDonald, great-grandson of George F. McDonald, is vice president of sales and business development. Founded in 1917, the company was located on Grand River Avenue between 1927 and 1934. (Courtesy of the Michigan State Fair.)

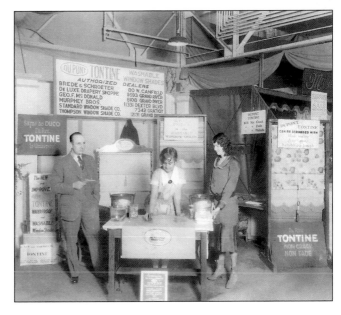

What could be more Michigan State Fair than homemade baked goods and a virtual cornucopia of produce? According to *Michigan. A Guide to the Wolverine State* by the Federal Writers' Project (FWP), attendance at the Michigan State fair in the 1930s exceeded that of any other state fair in the country—and this during the Great Depression. In 1939, around the time these photographs are thought to have been taken, paid attendance at the Michigan State Fair approached the half-million mark at 407,683. The FWP was created in 1935 as part of Pres. Franklin Roosevelt's New Deal. As part of the Works Progress Administrations, the FWP hired some 6,600 writers, editors, researchers, and scholars, including such notables as John Steinbeck and Studs Terkel. Based on the display of produce, Michigan farmers were, indeed, "Crowing about Growing." (Both courtesy of the Michigan State Fair.)

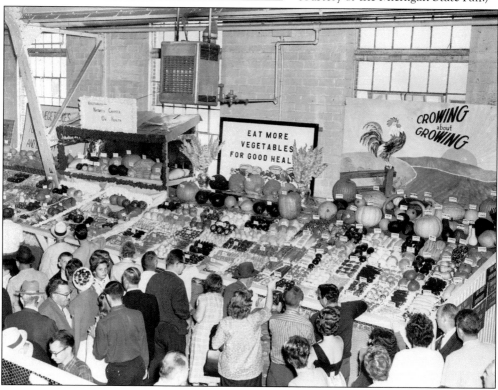

Three

PRE- AND POSTWAR YEARS

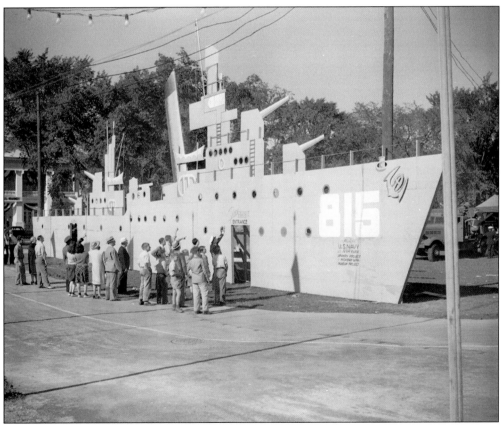

Appropriately enough, the 1941 Michigan State Fair—the last before the December 7, 1941, bombing of Pearl Harbor and the United States' entry into World War II—featured wooden miniatures of military craft, including this 120-foot-long model made by National Youth Administration artisans. The plywood model was said to be accurate in every detail. No state fair was held from 1942 through 1946. (*Detroit News*, courtesy of the Walter P. Reuther Library, Wayne State University.)

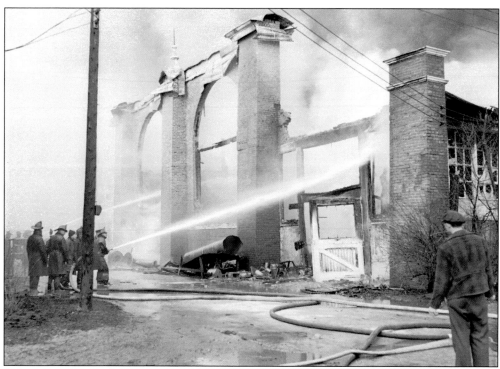

A five-alarm blaze called in at 11:25 a.m. on April 3, 1942, destroyed two buildings on the Michigan State Fairgrounds. The cause of the fire was determined to be careless smoking by one of the 30 boys working on a National Youth Administration project. The boys were painting steel lockers for use by the army and navy. Apparently several of the boys snuck a smoke in the paint room of the Electrical Building, which was against standing rules. At one point, some 1,200 to 1,500 new automobiles stored in nearby buildings following the war prohibition on new-car sales were at risk. The boys were noted for their quick action moving the automobiles to safety. At one point, even Gov. Murray D. Van Wagoner arrived at the scene and complimented the firefighters' efforts. (Both courtesy of the Walter P. Reuther Library, Wayne State University.)

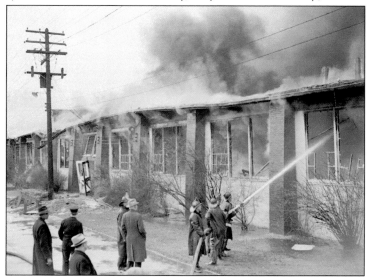

Firefighters continue to hose down hot spots in the aftermath of the April 3, 1942, fire that destroyed the Electrical Building and the former Ford exhibit building. It was found that poor water supply due to too small water mains supplying the fairgrounds hampered firefighters' efforts as competing fire department pumpers were "pumping water away from each other instead of on the fire." (Courtesy of the Walter P. Reuther Library, Wayne State University.)

Following the six-year World War II hiatus, the 1947 Michigan State Fair opened with enthusiasm, and WJR Radio, along with Detroit's other leading stations, was there to dedicate the reopening of the fair. On December 16, 1928, the station moved to the Fisher Building and began its famous call sign, "WJR Detroit, from the Golden Tower of the Fisher Building." (State Archives of Michigan, courtesy of the Michigan State Fair.)

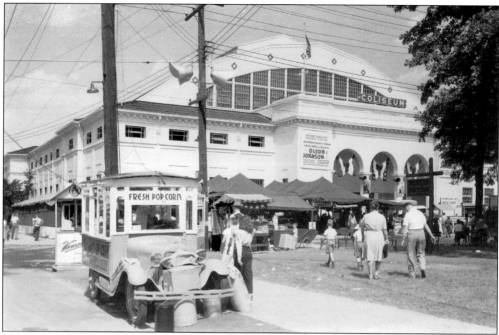

Perhaps no other building is more identified with the Michigan State Fair than the "Coliseum," shown here around 1947. The Michigan State Fair Riding Coliseum was built in 1922 and designed by Lynn W. Fry of the State Building Department. Along with the Agricultural and Dairy Cattle Buildings constructed in following years, it is a fine example of the neoclassical revival architecture inspired by the World Fair exhibitions popular in the 19th and early 20th centuries. The 5,600-seat multipurpose coliseum was also known as Hockeytown State Fair Coliseum and was home to the Wayne State University Warriors ice hockey team. The coliseum was also once the longtime host of the Shrine Circus. (Both State Archives of Michigan, courtesy of the Michigan State Fair.)

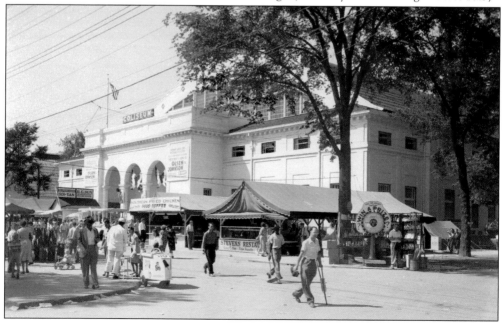

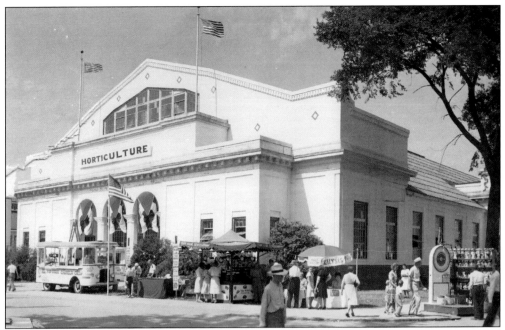

This *c.* 1947 photograph is a good view of the Horticulture Building (originally the Agricultural Building) constructed in 1926 under the direction of State Building Department architect Lynn W. Fry. It is another example of neoclassical revival architecture and is on the National Register of Historic Places. Today the building houses former Detroit Pistons star Joe Dumars's for-profit basketball field house. (State Archives of Michigan, courtesy of the Michigan State Fair.)

By 1947, the 4-H youth organization had grown to become such a strong presence at the Michigan State Fair that it warranted its own building. 4-H began in 1902 in Ohio and Iowa, and Michigan had its first two chapters just six years later. By 1936, the 4-H was a national movement with a million youth members. Originally focusing on corn and livestock, 4-H included other rural activities, including canning and baking. (State Archives of Michigan, courtesy of the Michigan State Fair.)

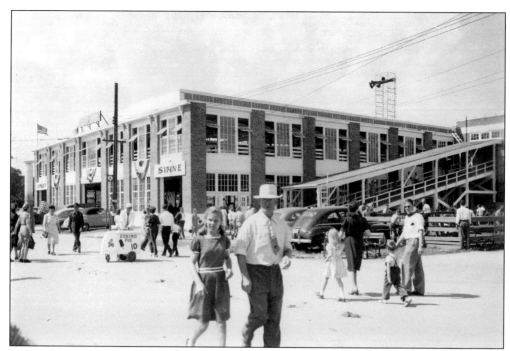

Perhaps unusual to agricultural fairs was the two-story Sheep and Swine Building (shown above around 1947) featuring a ramp necessary to herd animals to the second story. The Sheep and Swine Building disappeared after the 1983 fair. Nearby was the Poultry and Rabbit Building (pictured below around 1947). A flattering picture of the Michigan State Fair Poultry Building appears as early as 1921 in *Standard Poultry for Exhibition* by John Henry Robinson. (Both State Archives of Michigan, courtesy of the Michigan State Fair.)

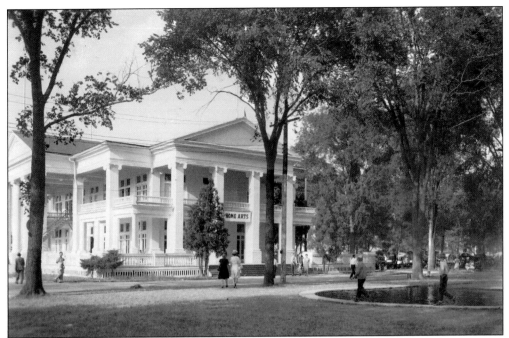

Formerly the Michigan Building, the Women's Building in 1947 housed the home arts displays, which included cooking, canning, decorating, sewing, quilting, and gardening. An earlier, undated photograph of the Women's Building included the "Better Babies" program. The Better Babies concept dates back to the 1911 Iowa State Fair. The idea arising out of the American Eugenics Society was that since farmers brought their products developed through selective breeding to the fair to be judged, why not judge the "human stock" to select the most "eugenically fit" family? The Fitter Family Contest, as the Better Babies program was also called, is mentioned at least as far back as 1917 at the Michigan State Fair and as recently as 1935. (Above, State Archives of Michigan, courtesy of the Michigan State Fair; below, courtesy of the Walter P. Reuther Library, Wayne State University.)

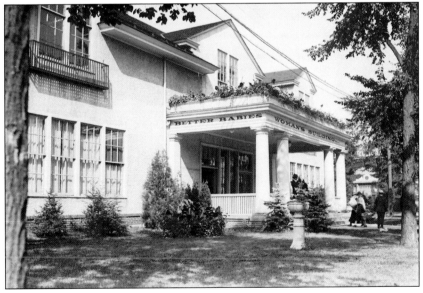

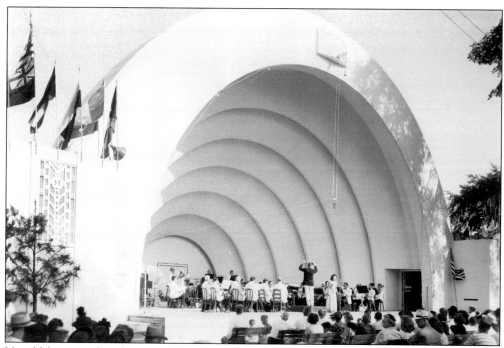

Untold legions of performers, groups, and bands—from the Works Progress Administration Symphony Orchestra, American Legion Juvenile Revue, the U.S. Marine Corps Drill Team Drum and Bugle Corps, and Michigan State Fair Honors Band to The Supremes and Bob Hope—have appeared at the Michigan State Fair Bandshell (pictured above around 1947 and below in 1941) since it was built in 1938. Other artists to appear in past decades include Johnny Cash, Glen Campbell, Ray Price, Tom Jones, Roy Rogers and Dale Evans, The Jackson Five, Tanya Tucker, Pat Boone, The Osmonds, Al Green, Bobby Vinton, Captain and Tennille, Tammy Wynette, The Oak Ridge Boys, Scooby Doo, Three Dog Night, Boyz II Men, ZZ Top, Air Supply, The Spinners, The Platters, and Alice Cooper. (Above, courtesy of State of Michigan Archives; below, courtesy of the Walter P. Reuther Library, Wayne State University.)

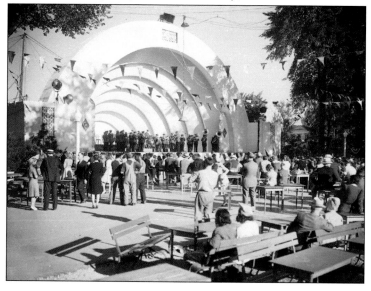

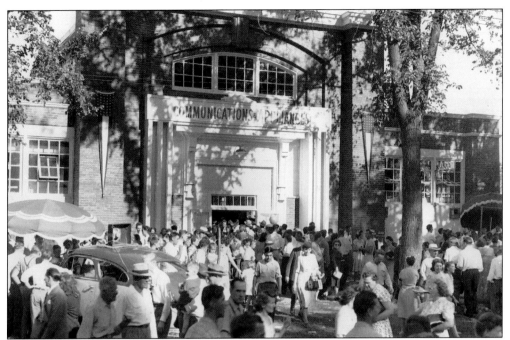

Pent-up demand for consumer products following World War II made the Communications and Appliances Building (above) a popular attraction in 1948. Schmidt's Gardens (below) at the 1948 Michigan State Fair bears the distinctive lowercase lettering of the Schmidt's Brewing Company of Detroit. Schmidt's was one of a handful of brewing companies to survive Prohibition and World War II. Predecessors of the company trace their roots back to 1872. The Schmidt's label was introduced in 1933 and was bottled in a plant at Wilkins and St. Aubin Streets near the Eastern Market area of Detroit. Sales during the war were brisk, reaching 300,000 barrels; however, by 1950, the number had fallen to 105,000 barrels due to postwar competition. Production ceased, and the Schmidt's label was sold to E&B Brewing Company, also of Detroit. (Both photographs by Snuffy McGill, courtesy of the Michigan State Fair.)

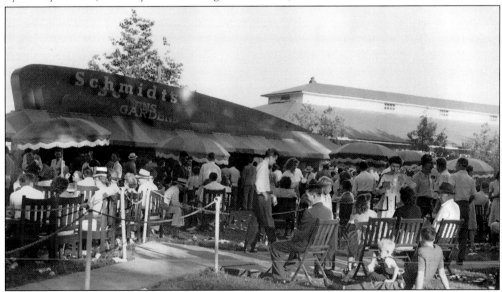

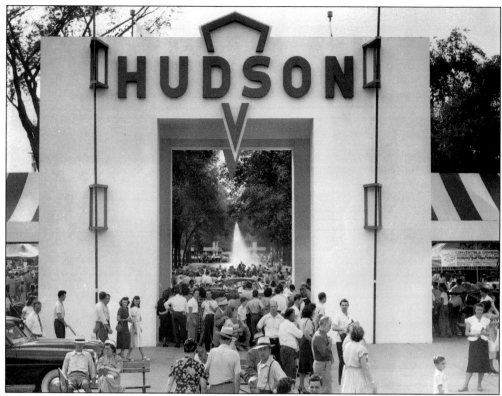

In 1948, the Hudson Motor Car Company introduced an innovation in the automotive world—the "step-down" body design, which allowed passengers to step down into the automobile since the floor of the vehicle was set lower than the chassis frame. The step-down design not only made the car more comfortable for passengers, it also made it safer and created better handling due to a lower center of gravity. The Hudson Motor Car Company was formed by eight investors, including department store magnate Joseph L. Hudson, the same man who secured land for the permanent Michigan State Fairgrounds in Detroit, who lent his name to the new motor car company. In 1954, Hudson merged with Nash-Kelvinator to become American Motors. The last Nash rolled off the assembly line in 1957. (Above, photograph by Frank Fulkersin Photography; both courtesy of the Michigan State Fair.)

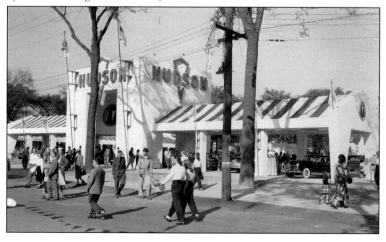

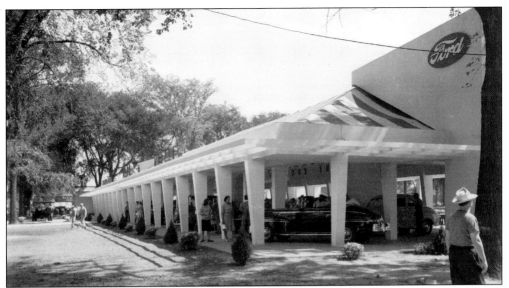

For the Ford Motor Company, 1947 was a sad year. Its legendary founder Henry Ford died of a cerebral hemorrhage on April 7 at the age of 83. In 1896, Ford built his first self-propelled vehicle, the Quadricycle. After two unsuccessful attempts, Ford incorporated the Ford Motor Company in 1903. In later years, he suffered ill health and ceded control of the company in 1945 to his grandson Henry Ford II. (State Archives of Michigan, courtesy of the Michigan State Fair.)

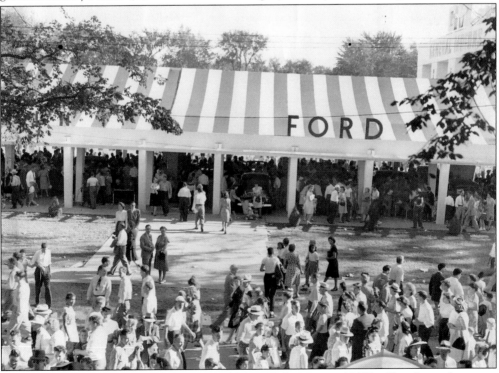

Since car production was halted during World War II, fairgoers in 1948 had barely anything new to look at except for, perhaps, Ford's new F-Series pickup, the F-1, also known as Ford Bonus-Built. (Photograph by Snuffy McGill, courtesy of the Michigan State Fair.)

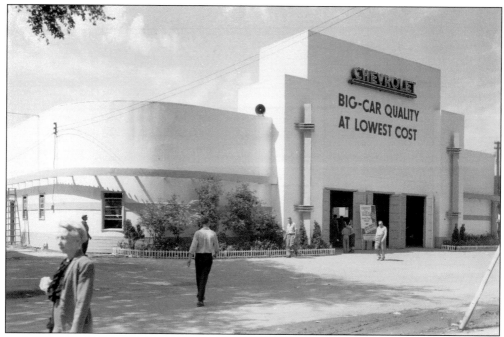

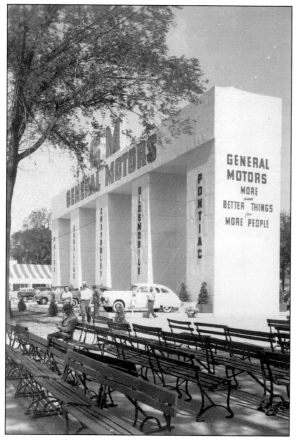

Chevrolet beat the competition in 1947 by being the first brand to come out with completely new postwar vehicles: the modern pickup and commercial trucks. Also in 1947, General Motors founder William C. Durant died in March. After forming GM in 1908, Durant lost control to bankers just two years later. Durant then partnered with Louis Chevrolet. The Chevrolet brand was so successful that Durant was able to buy out his partner and purchase enough shares of GM to regain control of the company. Durant again, however, lost control of General Motors in 1920 to the DuPonts. At the time of his death, Durant managed a bowling alley in Flint, Michigan. (Both State Archives of Michigan, courtesy of the Michigan State Fair.)

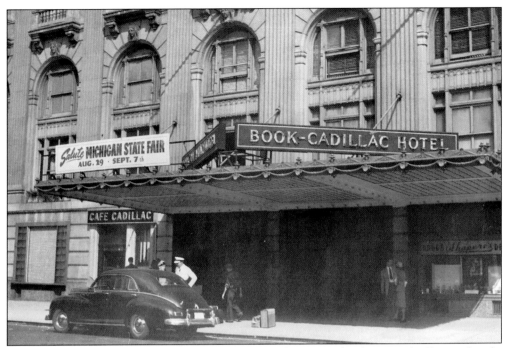

The Michigan State Fair was a big deal in 1948, and it meant big business for Detroit hotels, including the Book-Cadillac and Hotel Statler. When the 31-story Book-Cadillac was built on Washington Boulevard in 1924 by the Book brothers, it was the tallest building in the city and the tallest hotel in the world. The Book-Cadillac is where New York Yankees first baseman Lou Gehrig asked manager Joe McCarthy to bench him after collapsing on the hotel's grand staircase, ending a streak of 2,130 consecutive games played. The original 18-story (16 above ground) Detroit Statler Hotel, also on Washington Boulevard, was completed in 1915. Harry Houdini stayed at the Statler during his final performances at the Garrick Theater. Houdini died of a ruptured appendix on October 31, 1926, at the age of 52. After sitting vacant for 30 years, the Statler was demolished prior to Super Bowl XL, which was hosted by Detroit in 2005. (Both State Archives of Michigan, courtesy of the Michigan State Fair.)

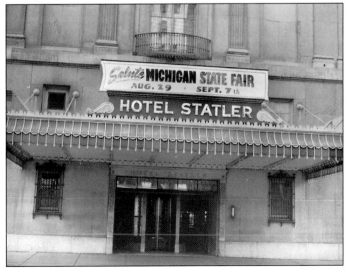

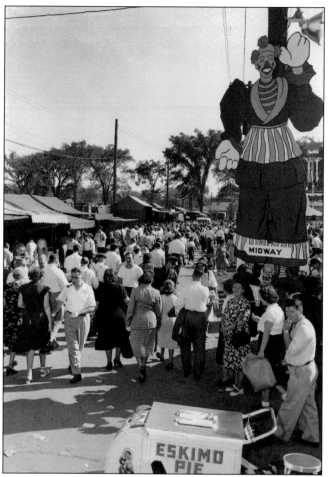

Welcome sights at the 1948 Michigan State Fair were the familiar midway clown and, especially during a warm late August/early September day, Eskimo Pie. The inspiration for a chocolate-coated ice cream bar came to Iowa schoolteacher and candy store owner Christian Kent Nelson in 1920 when he saw one of his young customers trying to decide whether to spend his money on a candy bar or ice cream. After experimenting with ways to get chocolate to adhere to ice cream, Nelson began selling his innovation under the name of "I-Scream Bars." In 1921, Nelson filed for a patent and contracted chocolate producer Russell C. Stover to mass produce Eskimo Pie, a name coined by Stover. Nelson became independently wealthy from his cool idea, and Stover went on to form Russell Stover Candies. (Both photographs by Frank Fulkersin Photography, courtesy of the Michigan State Fair.)

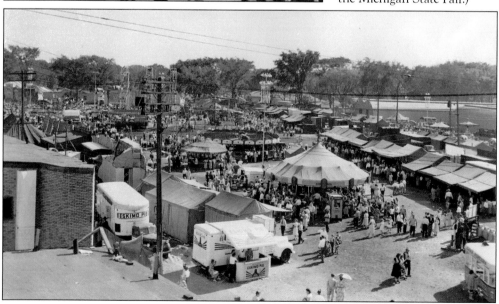

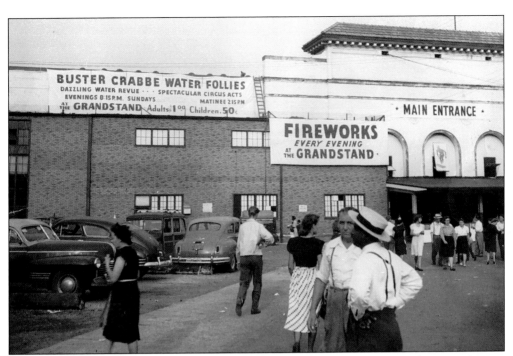

Clarence Linden "Buster" Crabbe was the Michael Phelps of his day. He won bronze and gold medals in the 1928 and 1932 Olympic Games. He played the title role in the 1933 *Tarzan the Fearless* and went on to star in more than 100 movies. He replaced Johnny Weismuller in the Billy Rose Acquacade at the 1940 New York World's Fair. His own water follies show was billed as the "World's Greatest Musical Revue in Water." Crabbe went on to become a successful stockbroker and businessman and founded his own swimming camp for youngsters aged 8 to 14 in the Adirondack Mountains in New York. (Both courtesy of the Michigan State Fair.)

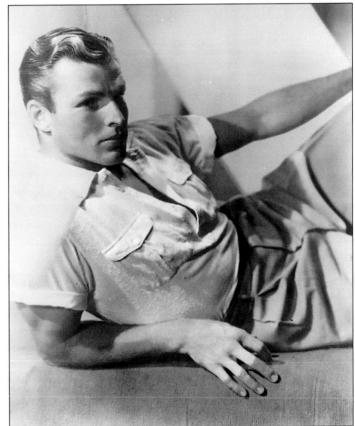

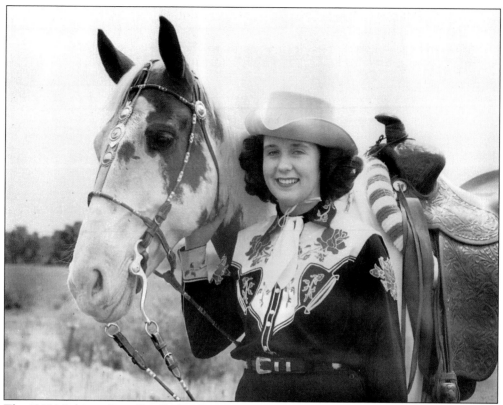

The 1948 Michigan State Fair Rodeo Queen Susan Clutter and her horse Topper were part of an equestrian square dancing troupe called Lee Clutter's Rambling Ranchers. The group was formed by Lee Clutter of Detroit in 1946 and had already gained wide popularity due to its colorful and interesting exhibitions, including a full two-set quadrille performed by 16 horses. A quadrille is a choreographed performance often set to music. A minimum of four horses is used, and often more. Though only in existence for two years, Lee Cutter's Rambling Ranchers had already performed at the Windsor (Ontario) Horse Show and the Romeo (Michigan) Peach Festival and was top ranked among quadrilles in the state. (Both photographs by Pherlo of Detroit, courtesy of the Michigan State Fair.)

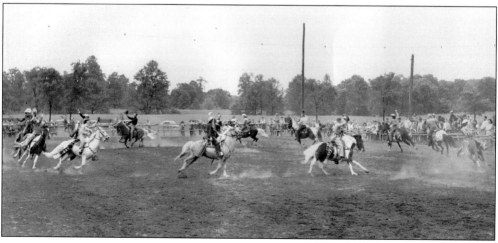

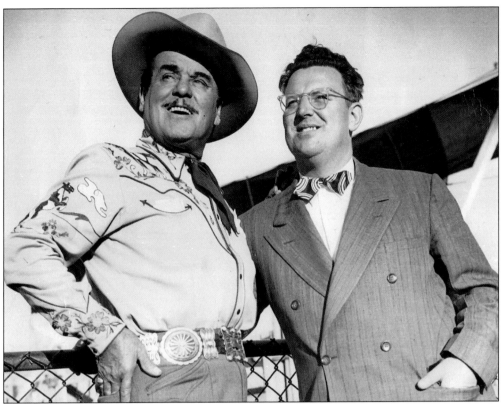

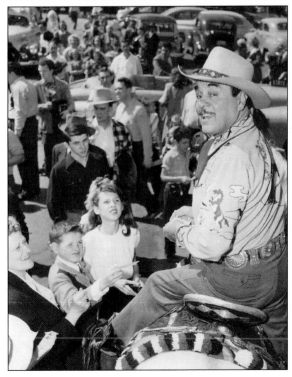

Motion picture actor Leopoldo "Leo" Carrillo headlined the Wild West Show and Rodeo Grandstand attraction at the 1948 Michigan State Fair, where he was welcomed by State Fair general manager Hagen Funk and thousands of adoring fans. Though Carrillo starred in more than 90 films and comes from a respected California family that traces its roots to the conquistadors, he is best remembered today for his role as Poncho in *The Cisco Kid*, which he undertook at the age of 70. Starring Carrillo and Duncan Renaldo as Cisco, the popular syndicated series ran from 1950 to 1956. Carrillo died of cancer in 1961, and the Leo Carrillo State Park near Malibu, California, is named in his honor. (Both photographs by Frank Fulkersin Photography, courtesy of the Michigan State Fair.)

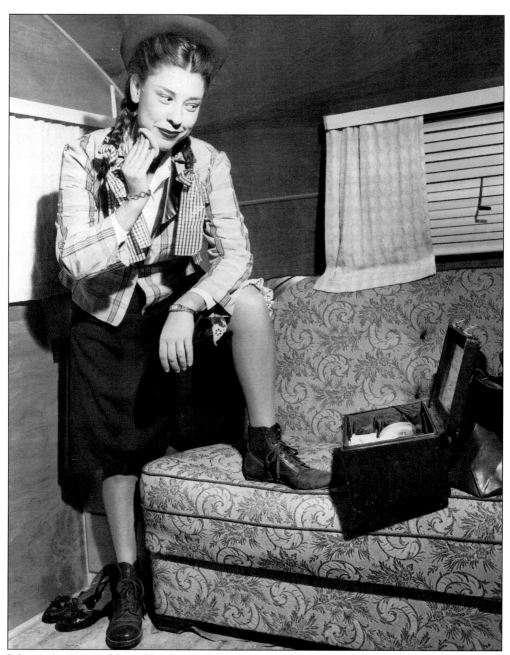

Juliette Canova and her siblings were known on stage as the *Three Georgia Crackers*. By 1945, *The Judy Canova Show* was one of the top 10 radio shows on the air. The show featured Canova as a love-starved Ozark bumpkin and included voice master Mel Blanc, whose voices would later become Looney Tunes characters. (Photograph by Frank Fulkersin Photography, courtesy of the Michigan State Fair.)

According to a 1948 advertisement in *Billboard*, "Folks packed the big Coliseum every night and matinee to see Judy Canova, her sister Annie, her brother Zeke and a terrific colorful revue staged by Ernie Young!" The crowds outside and inside the Coliseum at the Michigan State Fair attest to the accuracy of the *Billboard* advertisement. During World War II, Canova ended every show with the song "Goodnight, Soldier" and sold war bonds in her spare time. She also appeared in two dozen films. (Both photographs by Frank Fulkersin Photography, courtesy of the Michigan State Fair.)

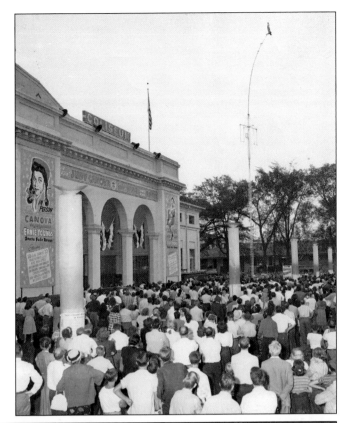

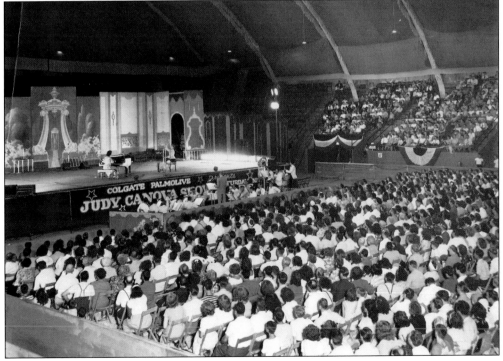

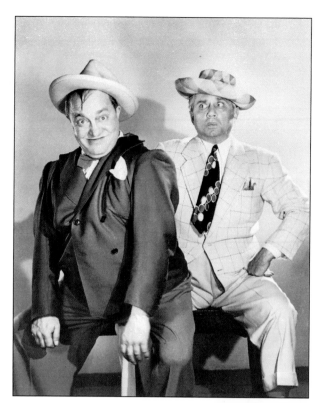

The comedy duo Olsen and Johnson brought their *Laffacade* revue to the Coliseum at the 1947 Michigan State Fair. At the time, the "zaniest of the zanies" out of the vaudeville tradition already had 10 films to their credit, including *Hellzapoppin*, an adaptation of the duo's smash Broadway hit. Their peak came in 1949 when NBC hired the two to host their own variety show, *Fireball Fun for All*. (Photograph by F. A. Russo, courtesy of the Michigan State Fair.)

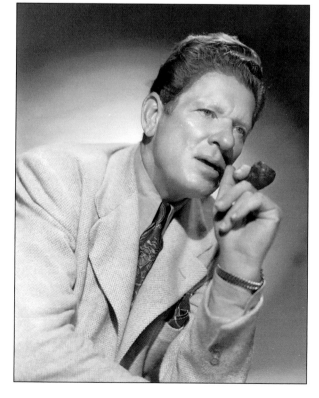

Robin "Bob" Burns and his *Arkansas Traveler* company also headlined at the 1947 Michigan State Fair. Burns, known as the "Arkansas Traveler" or the "Arkansas Philosopher," began his radio career as a self-effacing bumpkin with homespun stories about his kinfolk. He appeared in some nine films, including *Belle of the Yukon* with Randolph Scott, Gypsy Rose Lee, and Dinah Shore. (Photograph by NBC Photograph, courtesy of the Michigan State Fair.)

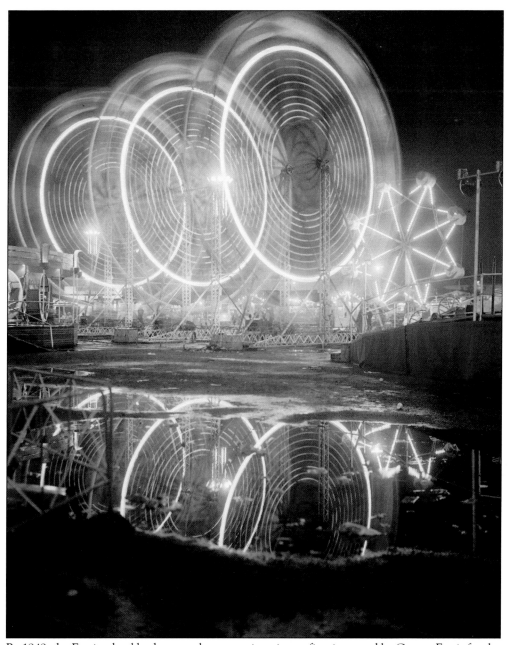

By 1949, the Ferris wheel had come a long way since it was first invented by George Ferris for the 1893 World's Columbian Exposition, also known as the Chicago World's Fair. The first portable Ferris wheel was put into production in 1906. No less than three Ferris wheels lit the night sky at the 100th anniversary Michigan State Fair in Detroit. (*Detroit News*, courtesy of the Walter P. Reuther Library, Wayne State University.)

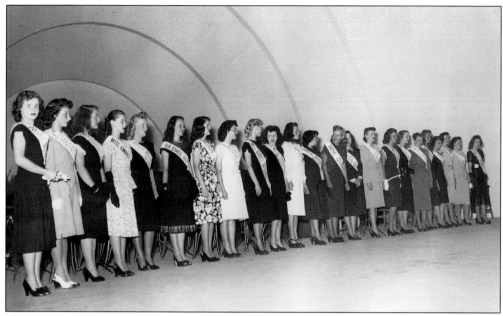

The Miss Michigan State Fair pageant was one of the oldest traditions of the Michigan State Fair. All contestants earned the opportunity to run in the pageant by becoming queens of other pageants around Michigan that year. Miss State Fair hopefuls line up on the stage of the Bandshell in 1948. The winner that year was the contestant farthest to the right. (Courtesy of the Michigan State Fair.)

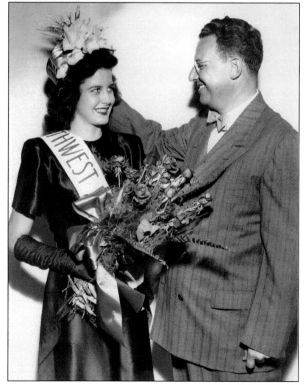

State fair general manager Hagen Funk got all the pleasant jobs. Here he crowns 17-year-old Sherrill Sudmann Miss Michigan State Fair 1947. Sudmann, a senior at Cooley High School, entered the contest as Miss Northwest Detroit. (Courtesy of the Michigan State Fair.)

Four

THE "BOOM" YEARS

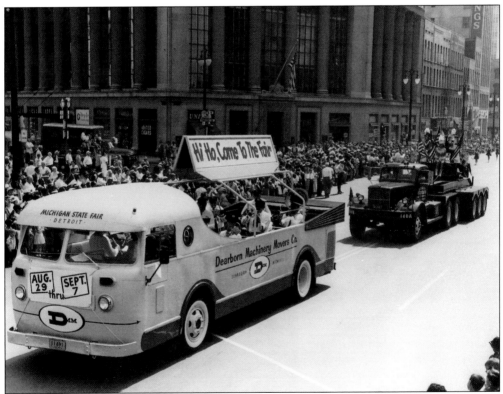

A Dearborn Machinery Movers Company truck leads the way, followed by what looks like a military vehicle ferrying majorettes, in the annual Michigan State Fair opening parade around 1958. Little is known of what happened to the moving company. In the background are signs for United Cigars and Mary Lee Candies. The cigar store chain was the largest in the nation, and its parent company would go on to own Marvel Comics. Mary Lee Candies is believed to have been founded in the 1920s by an English immigrant who came to Detroit via Toronto. (State Archives of Michigan, courtesy of the Michigan State Fair.)

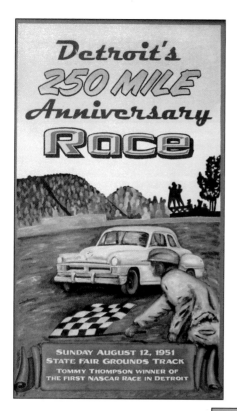

Having been founded in 1701, to celebrate Detroit's 250th anniversary a 250-mile NASCAR race was held on August 12, 1951, on the Michigan State Fairgrounds' 1-mile dirt track. The winner of the race was Tommy Thompson. The second and last Motor City 250 NASCAR race held at the state fairgrounds the following year was won by Tim Flock. The mural commemorating the 250th anniversary NASCAR event (pictured) was produced by a group called the Letterheads. (Photograph by John Minnis.)

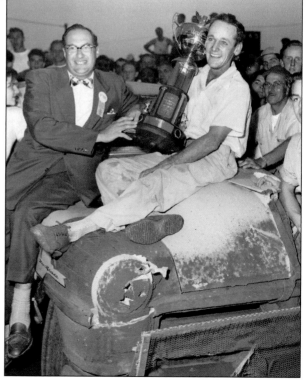

Tommy Thompson, winner of the 250 Mile Anniversary Race on August 12, 1951, at the Michigan State Fairgrounds sits on the hood of his 1951 Chrysler New Yorker. His was the first race won by a hemi-powered Chrysler and also the first hemi to win a NASCAR race. Besides a $5,000 cash prize, Thompson also won the race's official pace car, a brand new Packard. He is shown here receiving the trophy from Packard's vice president of sales. (Photograph by Snuffy McGill, courtesy of Roger Meiners.)

On September 4, 1958, a photographer caught this young boy fast asleep in the hay—er, straw—in the cattle barn at the Michigan State Fair. The boy fell asleep while reading a magazine featuring Roy Rogers and Trigger on its cover. Next to the magazine is another featuring "Walt Disney's Zorro." *The Roy Rogers Show* aired on television from 1951 to 1957 and featured Trigger, Roy's trusted steed; his faithful dog Bullet; and Dale Evans, Roy's real-life wife. *Walt Disney's Zorro*, featuring Guy Williams in the title role, was televised from 1957 to 1959. What adventures were in store for a boy at the 1958 Michigan State Fair? (Courtesy of the Walter P. Reuther Library, Wayne State University.)

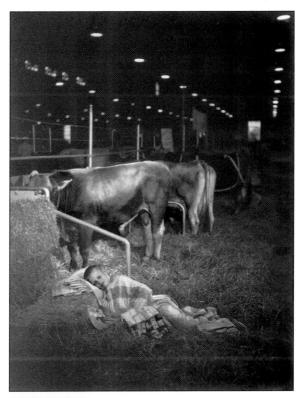

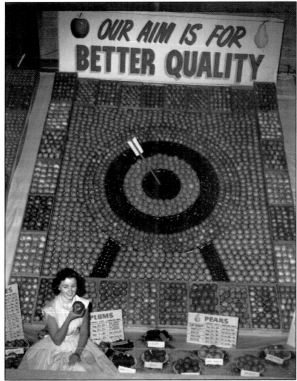

Michigan fruit growers hit the target at the 1957 state fair. A young woman displays apples, plums, and pears. Behind her is a huge fruit display made to look like an arrow hitting its target, while the header reads, "Our Aim Is for Better Quality." The young woman looks pleasantly tempted by the apple. (Courtesy of the Walter P. Reuther Library, Wayne State University.)

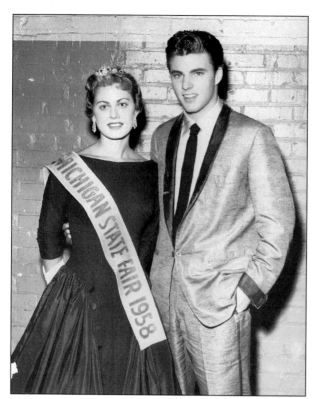

The 1958 Miss Michigan State Fair queen, 19-year-old Lila Verslype, poses with 18-year-old singer, musician, and actor Ricky Nelson. Verslype, of Harper Woods, Michigan, entered the Miss Michigan State Fair pageant as Miss Chiropractic, a title she received because of her perfect posture. Other titles Verslype held were Miss Michigan Posture, Miss Big Beat, and Miss Northland. (Courtesy of Lila Verslype Clause.)

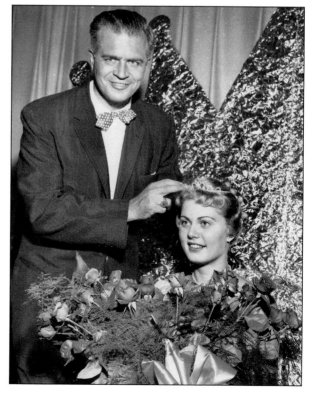

Lila Verslype is crowned by Michigan governor G. Mennen Williams as Miss Michigan State Fair of 1958. Newspapers at the time reported on beauty pageants quite differently from today, going so far as to detail her measurements. Some of the information reported included, "the 5 foot 4 Lila's well-distributed pounds placed her first in last Wednesday's contest. Her measurements are 35-23-35." (Courtesy of Lila Verslype Clause.)

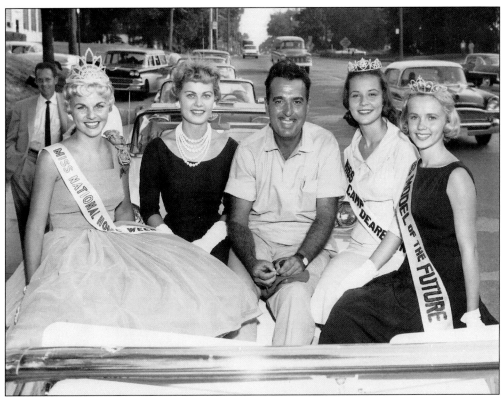

Lila Verslype, second from left, and her sister contestants ride in an open convertible with singer and television host Tennessee Ernie Ford. Verslype forgot her pageant sash for the car ride. Note the man in the background to the left—Lyle "Bud" Clause would one day marry the Michigan State Fair queen. Born on Christmas Eve, Verslype would become Mrs. Clause. (Courtesy of Lila Verslype Clause.)

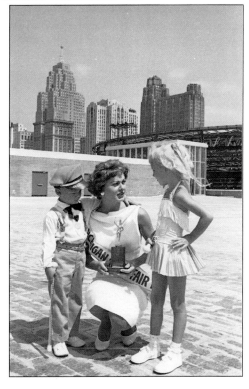

Duties of the reigning Miss Michigan State Fair queen included advertising the fair on television and radio and attending the following year's Michigan State Fair events. One year after her 1958 Miss Michigan State Fair crowning, Lila Verslype attended a baton-twirling competition at Cobo Hall. (Note what appears to be Cobo Arena under construction in the background.) Miss Michigan State Fair was also expected to assist the governor in crowning the next queen. (Courtesy of Lila Verslype Clause.)

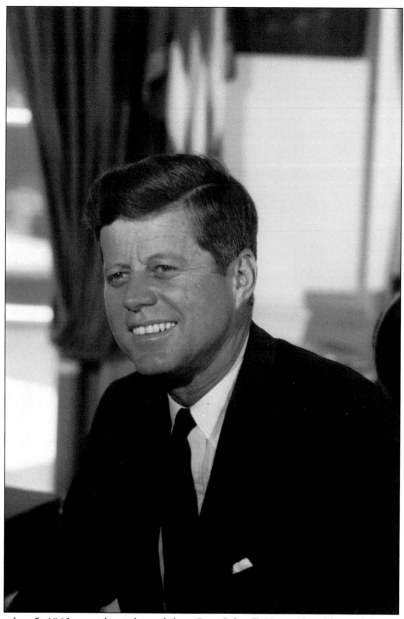

On September 5, 1960, presidential candidate Sen. John F. Kennedy addressed fairgoers to the Michigan State Fair, "This fair tells the story of America. It shows our dependence on the farms. It shows our dependence on the cities. I preach the doctrine of interdependence of the American economy, because this country cannot be prosperous unless the farmers and the workers are prosperous together. This is a great state, Michigan, but it can be a greater state. This is a great country, the United States, but it can be a greater country." Kennedy returned to the Michigan State Fair Coliseum on October 26, 1960, just two weeks before he was elected president of the United States. Present were Gov. G. Mennen Williams, Lt. Gov. John Swainson, U.S. senator Patrick McNamara, and U.S. representatives Thaddeus Machrowicz and James O'Hara. Kennedy was assassinated on November 22, 1963, in Dallas, Texas. (Photograph by Cecil Stoughton, Office of the Military Aide to the President, courtesy of the John F. Kennedy Presidential Library and Museum.)

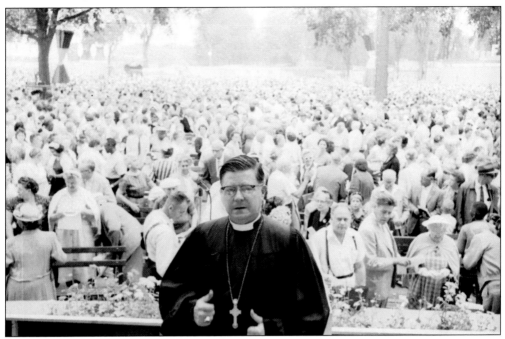

The annual sunrise services sponsored by the Detroit Council of Churches at the Michigan State Fair attracted crowds of 10,000 or more and some big-name clergy, such as The Right Reverend James A. Pike in 1960. Pike was the Episcopal Bishop of California and hosted television's first religious program for ABC. Raised Catholic and ordained Episcopalian, Pike became controversial when he questioned tenets of the faith. He died while on a pilgrimage to the Holy Land with his wife in 1969. His car broke down in the Judean Desert, and he succumbed while going for help. (Courtesy of the Walter P. Reuther Library, Wayne State University.)

The Ford Mustang was first unveiled to the public on April 17, 1964, at the New York World's Fair. Originally expected to sell 100,000 units in its first year, Ford actually delivered a million Mustangs within the first 18 months. In recent years, the Mustang continued to be a draw at the Michigan State Fair. (Courtesy of the Michigan State Fair.)

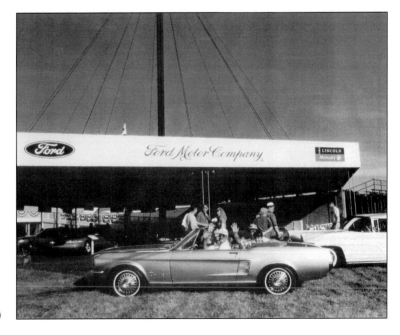

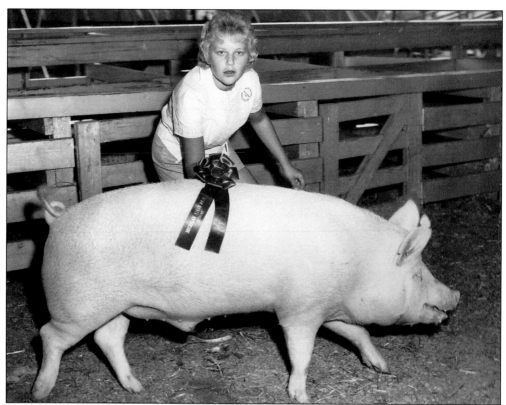

Kathy Jickling, 13, of Kingston, Michigan, proudly shows off her February boar, which won junior champion at the 1963 Michigan State Fair. Five years later, Jickling's champion March boar at the 1968 Michigan State Fair sold for $1,600. Jickling is typical of thousands of farm youth and 4-H members over the years who raised livestock and competed every year at the Michigan State Fair, not only for ribbons but for profit. (Below, by Dick Frederick, *Detroit Free Press*; both courtesy of Kathy Jickling Matuszak.)

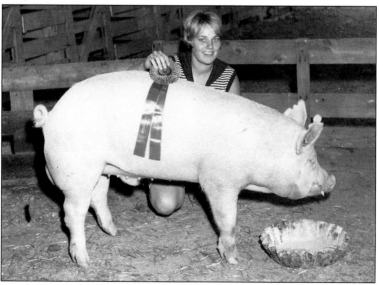

The Temptations, one of the most successful groups in music history, were regulars at the Michigan State Fair up to and including the fair's final year, 2009. The group was named by Berry Gordy, founder of Motown. Over the years, there have been some 21 Temptations besides Otis Williams, the sole surviving original member of the group. (Courtesy of Bob Harris.)

A dancing and musical group, The Kittens, featuring five tall, blond women (standing), played backup for Detroit rhythm-and-blues singer George "Gino" Washington (standing fourth from right) at the 1967 Michigan State Fair. (Several fans and friends joined in the photograph.) Washington is best known for his 1963 and 1964 hits "Out of This World" and "Gino Is a Coward." (Courtesy of Bob Harris.)

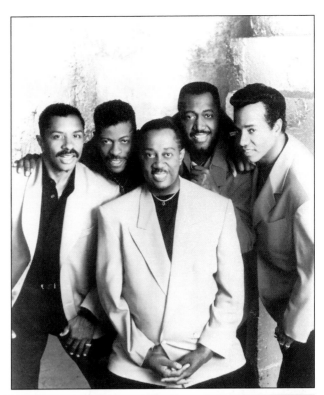

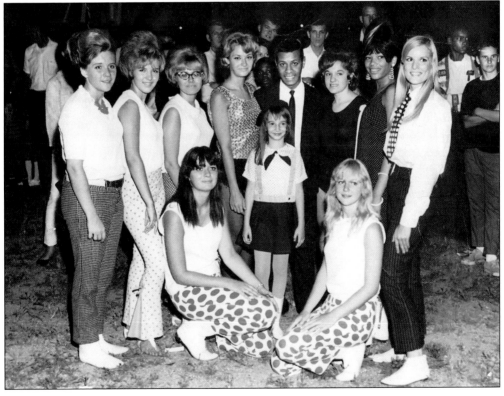

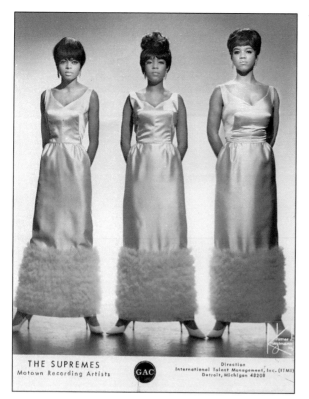

THE SUPREMES
Motown Recording Artists

GAC

Direction
International Talent Management, Inc. (ITMI)
Detroit, Michigan 48208

The 1960s and 1970s were a golden era for Michigan State Fair entertainment. The Supremes, originally composed of Diana Ross, Mary Wilson, and Florence Ballard, performed at the Michigan State Fair in 1967. Each member of the original Supremes was born in Detroit. In 1965, Ballard left the group, allowing Cindy Birdsong to take her place. In order to pursue a solo career, Diana Ross left the group in 1969, and 1976 saw the end of a legendary singing trio. (Courtesy of Bob Harris.)

Gladys Knight and the Pips performed at the Michigan State Fair in 1968 and 1972. The Motown group climbed the charts with hits like "Every Beat of My Heart" and "Midnight Train to Georgia." Knight was eight years old when she became the lead singer of her family's rhythm-and-blues group in 1952. The Pips, including Knight's brother Merald "Bubba" Knight and cousins Langston George and Edward Patton, were named after her manager and cousin, James "Pip" Woods. (Courtesy of Bob Harris.)

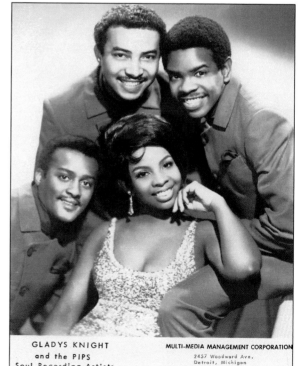

GLADYS KNIGHT
and the PIPS
Soul Recording Artists

MULTI-MEDIA MANAGEMENT CORPORATION
2457 Woodward Ave.
Detroit, Michigan

74

Motown legends Smokey Robinson and the Miracles performed at the Michigan State Fair in 1968. William "Smokey" Robinson was born in Detroit in 1940. The Miracles included his ex-wife Claudette Rogers, Bobby Rogers, Ronnie White, and Warren Moore. With hits like "Shop Around," "Love Machine," and "I Second That Emotion," Smokey Robinson and the Miracles produced the first million-selling hit single for Motown. Robinson was inducted into the Rock and Roll Hall of Fame in 1987. (Photograph by Pierre Bass, courtesy of Bob Harris.)

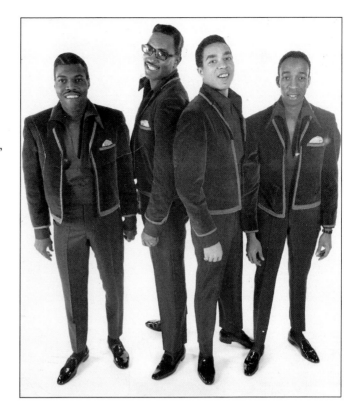

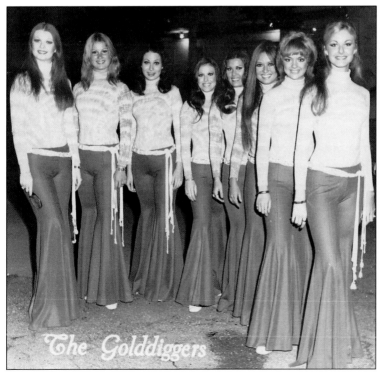

The singing and dancing troupe The Golddiggers debuted on the *Dean Martin Show*—and at the Michigan State Fair—in 1968. Originally comprised of 12 girls, The Golddiggers varied from 4 to 13 members. Though the Golddiggers performed in the style of Las Vegas showgirls, they were chosen for their wholesome and attractive looks, talent, and presence. (Courtesy of Bob Harris.)

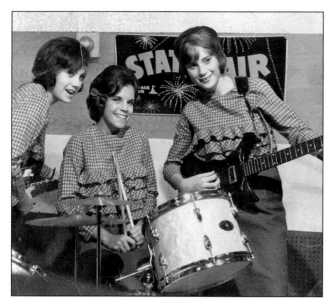

The Debutantes came on the Detroit scene in 1964 soon after Jan McClellan (left) had seen The Beatles on the *Ed Sullivan Show* and had the idea of forming her own girls band. She was joined by Diane Abray (center) and Lynn Hawkins (right). The Debutantes successfully auditioned for the Michigan State Fair Teen Scene and took part in a photography shoot at Hitsville USA, birthplace of Motown in Detroit, to promote the fair. The Debutantes also performed for troops at the fairgrounds during the 1967 riots in Detroit. (Courtesy of Bob Harris.)

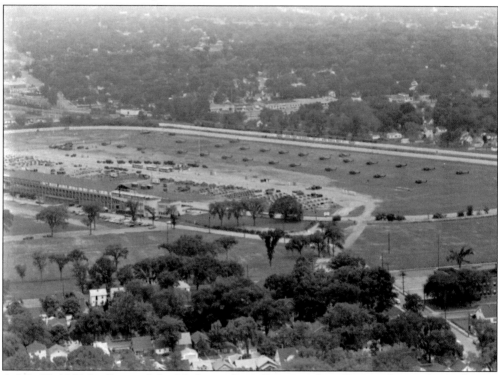

A July 27, 1967, bird's-eye of the Michigan State Fairgrounds in Detroit during the 1967 riots shows many helicopters parked in background. The National Guard was mobilized, followed by the 82nd Airborne. At the conclusion of five days of rioting, 43 people lay dead, 1,189 were injured, and more than 7,000 had been arrested. Detroit and the Michigan State Fair would never again be the same. From an all-time record of 1.2 million in 1966, attendance fell to 217,000 in the fair's penultimate year of 2008. (*Detroit News*, courtesy of the Walter P. Reuther Library, Wayne State University.)

Five

THE "BUST" YEARS

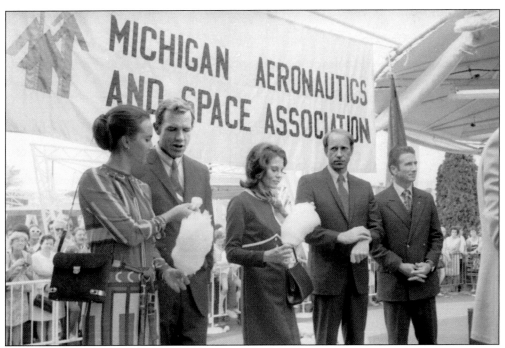

An exhibit by the Michigan Aeronautics and Space Association at the 1971 Michigan State Fair featured the Apollo 15 astronauts and their wives. Pictured from left to right are Lurton and Col. David R. Scott, Mary and Lt. Col. James B. Irwin, and Maj. Alfred M. Worden. The Apollo 15 crew (Scott and Irwin) had just returned from walking on the moon July 31 and August 2 and 3. Worden piloted the Command Module. (Courtesy of the Walter P. Reuther Library, Wayne State University.)

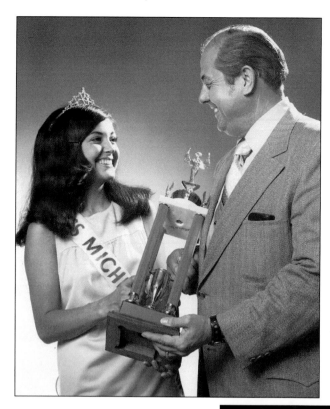

Twenty-year-old Michelle Nesbit of Detroit was crowned Miss Michigan State Fair in 1970. Director of entertainment Harold Arnoldi presents Nesbit with a Miss Michigan State Fair trophy. A kitchen designer and market representative, she was selected out of 52 women. (Photograph by Jerry Dempnock, courtesy of Kyle Arnoldi Jolley.)

Leonna Bear was crowned Miss Michigan State Fair in 1971. The 19-year-old from Mount Pleasant, Michigan, beat out more than 50 women for the title. Harold Arnoldi, director of entertainment, and Leonna pose at the 1972 Michigan State Fair as Bear fulfills her Miss Michigan State Fair duties of involvement at the state fair one year after her crowning. (Photograph by Douglas G. Ashley, courtesy of Kyle Arnoldi Jolley.)

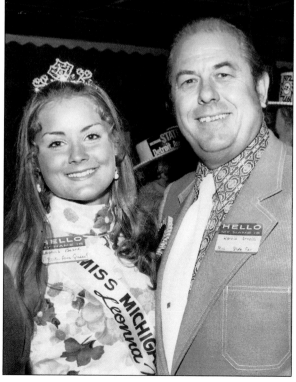

Bob Hope poses with the 1972 A.P.A. Queen. While the young lady appears to be in Polish dress, no record could be found on what "A.P.A." stood for or who the attractive girl was. (Photograph by Richard F. Lind Photography, courtesy of Bob Harris.)

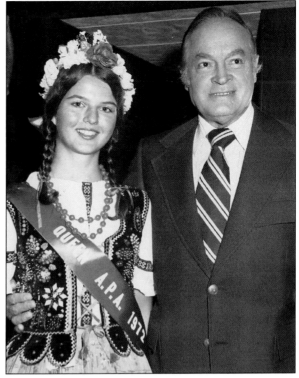

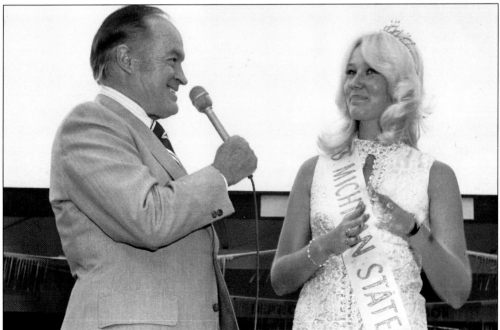

In 1972, the title of Miss Michigan State Fair went to 19-year-old Patricia K. Loftis of Detroit. Bob Hope, a regular at the Michigan State Fair, is seen here speaking with Loftis. Before passing the preliminary stages and then the final competition, Loftis was 1 of 54 women to enter. (Photograph by Richard F. Lind Photography, courtesy of Bob Harris.)

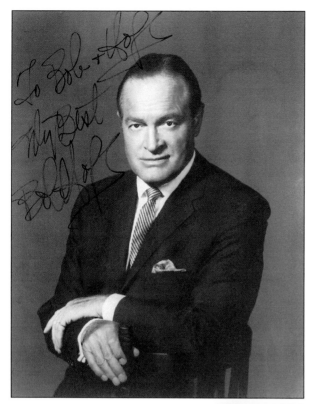

Bob Hope was a frequent visitor to the Michigan State Fair. In 1949, the fair's centennial anniversary year, Hope shared ribbon-cutting duties with cowboy star Tex Ritter, Gov. G. Mennen Williams, Detroit mayor Van Antwerp, and fair general manager James D. Friel. The famous comedian returned to the Michigan State Fair in 1971 and 1972, during which he signed a photograph for entertainment promoter Bob Harris and his wife, Hope—hence the confusing words, "To: Bob & Hope; My Best, Bob Hope." (Courtesy of Bob Harris.)

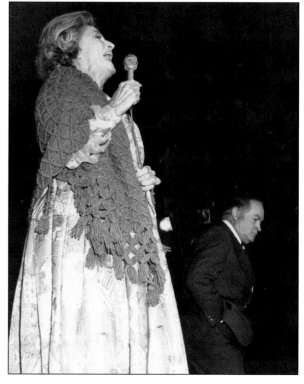

Dolores Hope was a devoted wife and mother who traveled all over the world with her husband, including to USO tours for U.S. troops in Korea, Vietnam, and the Persian Gulf. She also accompanied her husband to the Michigan State Fair in 1971 and 1972 and even took the stage. The Hopes raised four adopted children and were married for nearly 70 years. Bob Hope died in 2003, having reached the age of 100. Dolores turned 101 in May 2010. (Photograph by Richard F. Lind Photography, courtesy of Bob Harris.)

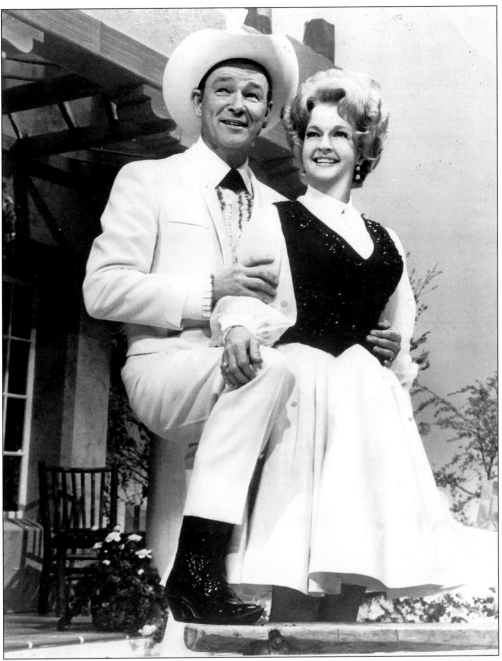

Roy Rogers and Dale Evans were favorites of youngsters and adults alike at the 1971 Michigan State Fair. Roy, born Leonard Franklin Slye, was a singer and cowboy actor. He was featured in more than 100 movies with his golden palomino, Trigger, and his German shepherd, Bullet. The *Roy Rogers Show* aired for nine years on radio before moving to television from 1951 through 1957. Rogers was known as "King of the Cowboys," while Evans's nickname was "Queen of the West." In the fall of 1962, the couple cohosted a comedy-western-variety program, the *Roy Rogers and Dale Evans Show*, on ABC. Their famous theme song, "Happy Trails," was written by Evans, and they sang as a duet to sign off their television show. (Courtesy of Bob Harris.)

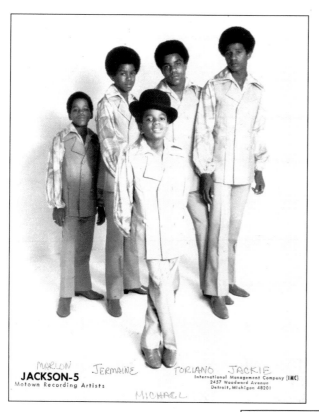

The Jackson Five performed at the Michigan State Fair in 1971. Members included Michael, Marlon, Jermaine, Toriano (Tito), and Sigmund (Jackie). They were known as the Jackson Five from 1965 to 1975 and recorded such songs as "ABC" and "I'll Be There." In 1969, the group changed to include Jackie, Tito, Jermaine, and Randy Jackson. Michael went solo in 1971 with Motown and would become the "King of Pop." Both Michael Jackson and the Jackson Five were inducted into the Rock and Roll Hall of Fame. (Courtesy of Bob Harris.)

The Fifth Dimension, a Los Angeles–based Grammy-winning group, performed at the Michigan State Fair in 1970 and 1971. Composed of Florence LaRue, Marilyn McCoo, Billy Davis Jr., Lamont McLemore, and Ron Townson, the Fifth Dimension released their biggest hit, "Aquarius/Let the Sunshine In," in 1969. Their rhythm-and-blues, soul, and jazz sounds earned them 30 top-100 hits. (Courtesy of Bob Harris.)

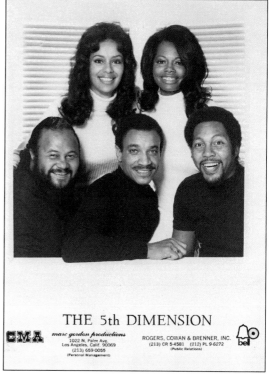

Glen Campbell performed at the Michigan State Fair in 1971, the year the Grandstand was declared unsafe by a Wayne County circuit judge. He consequently performed on a makeshift stage in the pouring rain. With hits like "Gentle on My Mind" and "By the Time I Get to Phoenix," Campbell won Grammys in both the country and pop categories. Not solely known for his musical career, Campbell also found fame with his variety show, called the *Glen Campbell Goodtime Hour*, which ran from 1969 to 1972. He was inducted into the Country Music Hall of Fame in 2005. (Courtesy of Bob Harris.)

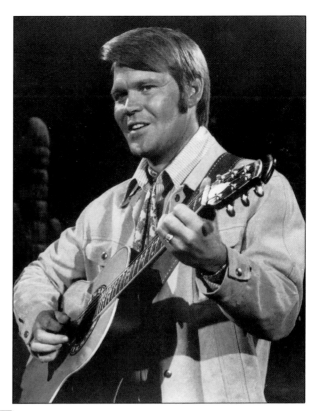

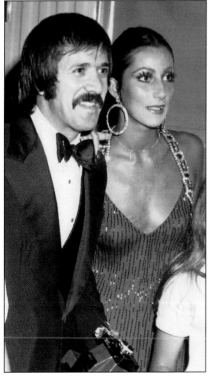

This photograph of Sonny and Cher, the husband and wife singing duo, was taken at the 1972 Michigan State Fair. Their popularity skyrocketed after releasing the hit "I Got You Babe" in 1965. Married in 1963, the couple divorced in 1974. Sonny died in a skiing accident in 1999 and Cher continues to perform today. (Richard F. Lind Photography, courtesy of Bob Harris.)

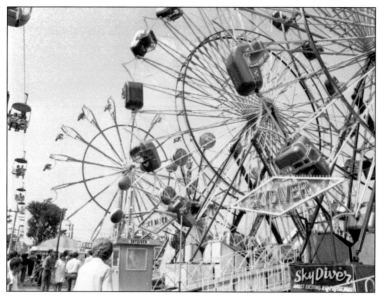

Not one, not two, but three Ferris wheel–like rides were featured at the 1970 Michigan State Fair. The Skydiver, produced from 1965 to 1979 by Chance Rides Manufacturing Incorporated in Wichita, Kansas, featured cars that spin on an axis like a barrel roll. (*Detroit News*, courtesy of the Walter P. Reuther Library, Wayne State University.)

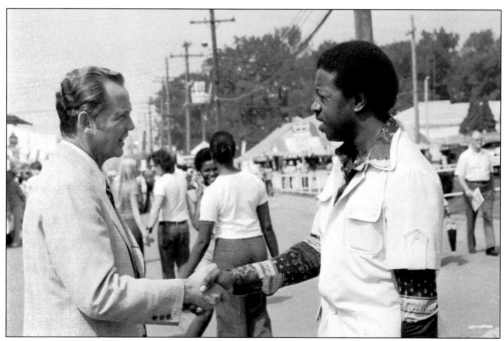

Michigan governor William G. Milliken (left) took time to introduce himself during Governor's Day at the 1977 Michigan State Fair. The governor told the press that he would seek funding from the legislature in order to keep the state fair in Detroit. The unacceptable alternatives, he said, were to abandon the state fair, sell the property, or move. (*Detroit News*, courtesy of the Walter P. Reuther Library, Wayne State University.)

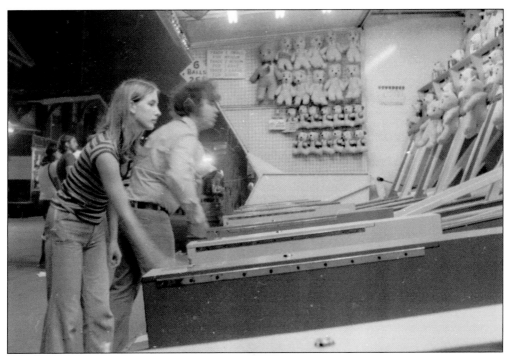

Since 1914, Skee-Ball has been a popular staple of midways throughout the United States, including the Michigan State Fair. Skee-Ball is a game of skill and chance for which prizes are awarded. Now a competitive sport in North America, the first ever Skee-Ball tournament was held in 1932 in Atlantic City, New Jersey. In 2005, Brewskee-Ball created the first-ever Skee-Ball league in a New York City bar. Noting the "Starsky" (of *Starsky and Hutch*) hairstyle, pattern shirt, and monster bell-bottoms, these photographs appear to have been taken during the 1970s at the Michigan State Fair. (Both courtesy of the Walter P. Reuther Library, Wayne State University.)

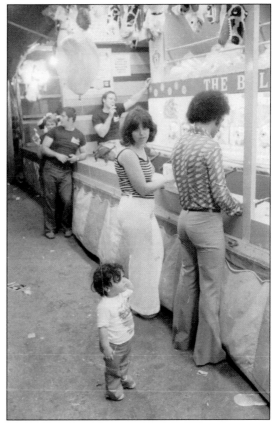

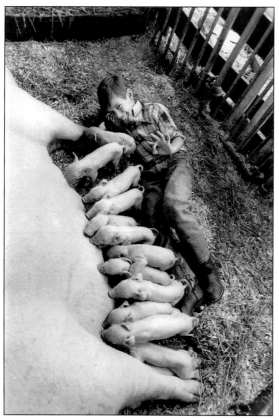

This farm boy looks quite satisfied with his sow's litter of 12 piglets—duodecaplets—at the Michigan State Fair. A dozen mouths to feed at one time is not unusual; pig litters average between 8 and 14 piglets, and a sow may have as many as three litters a year. As any farm boy or girl knows, the gestation period of a gilt or sow is usually "three months, three weeks, and three days" (roughly 112–115 days). (Courtesy of the Michigan State Fair.)

Jeff MacNaughton, age 10, of Grand Ledge sleeps on his prize-winning heifer at the Michigan State Fair in 1985. (*Detroit News*, courtesy of the Michigan State Fair.)

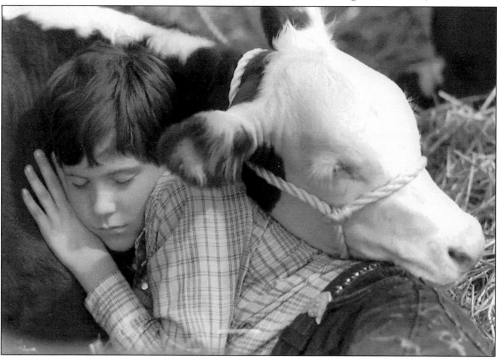

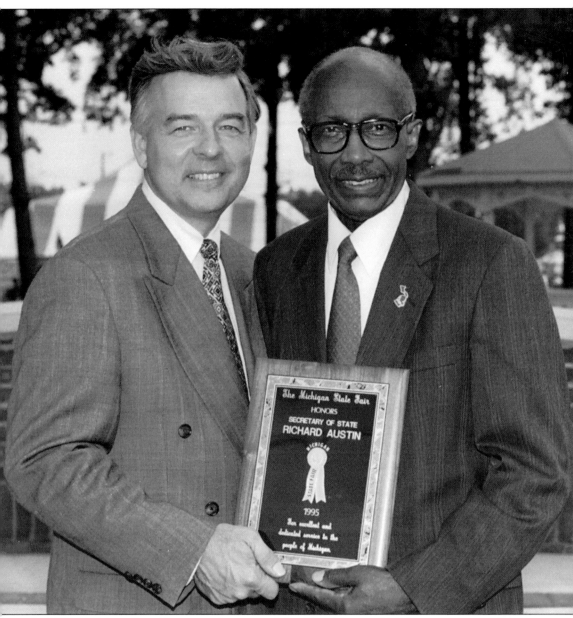

In 1995, Michigan State Fair general manager John Hertel honored Michigan secretary of state Richard Austin "for excellent and dedicated service to the people of Michigan." Elected in 1970, Austin was the first African American to hold a statewide elected position in Michigan. He served as the Michigan secretary of state for 24 years, successfully working for the mandatory use of seat belts and child safety seats. Prior to 1970, he served as a delegate to the 1962 Michigan Constitutional Convention and unsuccessfully for Congress in 1964 and mayor of Detroit in 1969. His tenure as secretary of state ended when he was defeated for re-election in 1964. Austin died from Alzheimer's disease in 2001 at the age of 87. (Courtesy of the Michigan State Fair.)

General manager John Hertel opened the "150th Anniversary" Michigan State Fair in 1998. Technically the 150th anniversary would not occur until 1999, some 150 years after the first Michigan State Fair in 1849. The fair of 1998 could have been considered the 150th fair; however, even that would not be accurate since there were no fairs in 1893 and during World War II. Nevertheless, countless dignitaries were on hand for the "150th Anniversary" fair, including Michigan secretary of state Candice Miller, shown cutting the ribbon. (Both photographs by Tonya Boyer, courtesy of the Michigan State Fair.)

Viewers of this vintage car parade at the 1998 Michigan State Fair probably did not realize they were watching the future drive by. This c. 1914 Detroit Electric vehicle was advertised to get 80 miles per charge and reach a top speed of 20 miles per hour. Ironically, electric vehicles are back on the drawing boards today. (Photograph by Tonya Boyer, courtesy of the Michigan State Fair.)

The 1998 Michigan State Fair featured all the typical contests, including bubble blowing. It is not recorded who won the 1998 contest, but it is known that Susan "Chewsy Suzy" Montgomery Williams of Fresno, California, holds the Guinness World Record for the 23-inch bubble she blew in 1994. She died in October 2008 at the age of 47 of an aneurysm, apparently unrelated to her bubble blowing. (Photograph by Tonya Boyer, courtesy of the Michigan State Fair.)

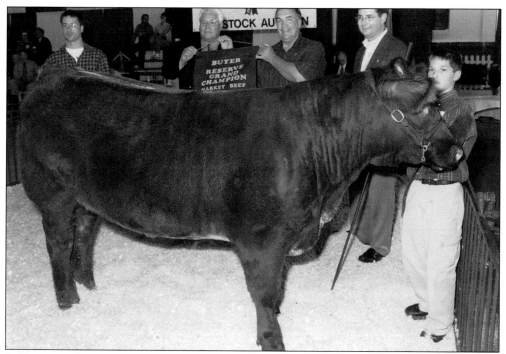

In "farm casual" attire, Michigan governor John Engler (above, center) shares the honor of awarding the 1999 Buyer Reserve Grand Champion Market Beef prize during the Youth Livestock Auction, while the governor (below, right) reaches over to pat the Grand Champion hog at the 1999 Michigan State Fair. The Michigan State Fair Youth Livestock Auction and Governor's Luncheon has grossed more than $1.2 million for Michigan youth in agriculture. The success of this auction led to the creation of the Michigan Youth Livestock Scholarship Fund (MYLSF). Since 1999, the MYLSF has awarded more than $96,000 in scholarships and educational awards to more than 400 exhibitors at the Michigan State Fair. (Both courtesy of the Michigan State Fair.)

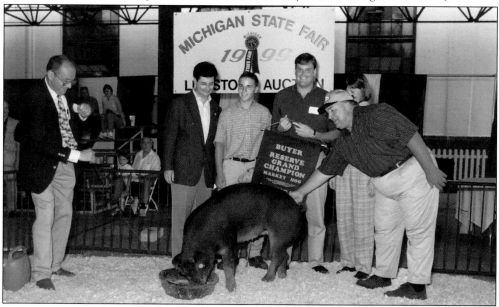

Kids were what the Michigan State Fair was all about, and the 1999 fair was no exception. The family-friendly elephant ride was designed and built by Zamperla Rides, founded in 1960 in Italy, while the American branch was founded in 1970. Zamperla focused on family-friendly rides that could be easily mass-produced, taken down, and transported to different locations. With origins possibly as far back as the 19th century, "hot potato" remains a popular children's party game as well as an activity for practicing motor skills such as hand-eye coordination and catching. (Both courtesy of the Michigan State Fair.)

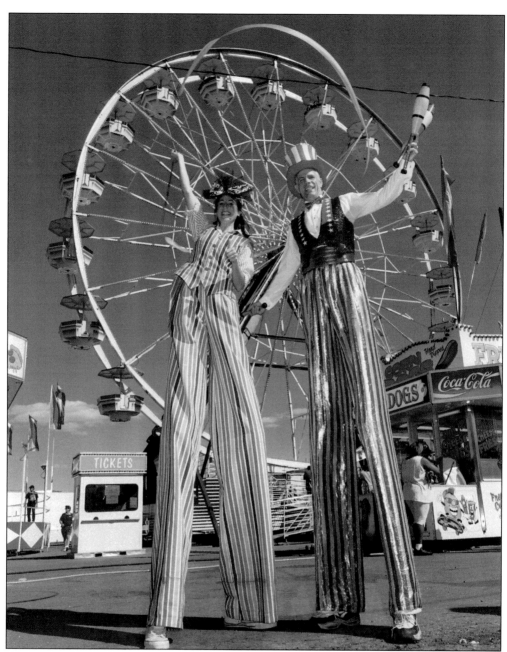

The millennial Michigan State Fair in the year 2000 was larger than life. Stilt-walking dates back to the first half of the 19th century in the Galcony region of southwest France, where stilts provided a practical means of traversing the swampy terrain. A 19th-century painting by Jean Louis Gintrac shows inhabitants of Landes walking on stilts. The stars-and-stripes likeness of Uncle Sam dates back to Thomas Nast, a leading 19th-century political cartoonist who also created the Republican elephant and the Democratic donkey. Even though the new millennium did not begin until the year 2001, in most folks' minds 2000 was the eventful year. The 2000 Michigan State Fair employed some 20 full-time and 58 temporary workers and saw 373,418 attendees walk through the gates. (Courtesy of the Michigan State Fair.)

The 2000 Michigan State Fair featured a double Ferris wheel. This adaptation of Ferris's original 1893 invention was called the Sky Wheel or American Sky Wheel. Carrying some 32 passengers 85 feet up in the night air, it is no wonder the Sky Wheel was known as "King of the Midway." The Crazy Dance was another popular ride among midway aficionados. It featured a tilted platform that rotated in one direction while cars mounted on four separate discs rotated in the opposite direction. The 2000 midway also included a huge observation wheel with some 18 or 20 gondolas and White Water, an early version of the modern water log ride. (Both courtesy of the Michigan State Fair.)

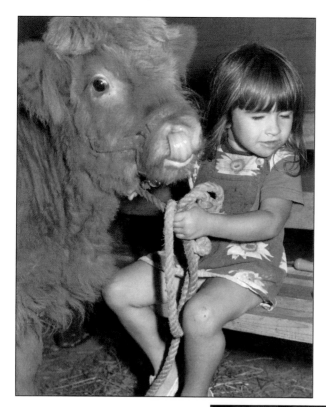

This Scottish Highland calf found this little girl at the 2000 Michigan State Fair to be sugar and spice and everything nice. Highland cattle are favorites at petting zoos and farms because they are kind, gentle, and people-friendly. For centuries, Highland cattle have been domesticated by Scots, and they are becoming increasingly popular among cattle growers in the United States. (Courtesy of the Michigan State Fair.)

All girls love horses, and there were plenty to love at the 2000 Michigan State Fair. The girl's T-shirt indicates she is a member of the Michigan Department of Natural Resources' Outdoor Explorers Club. Four times a year Outdoor Explorers Club members receive newsletters filled with eye-grabbing graphics and colorful cartoon characters that lead youngsters to appreciate Michigan's natural resources and become active participants in enjoying Michigan's natural world. (Courtesy of the Michigan State Fair.)

Kids were always intrigued by the annual Miracle of Life exhibit at the Michigan State Fair. The exhibit featured live births of calves, chickens, lambs, and piglets. In 2000, the Miracle of Life exhibit witnessed the births of 12 calves, 22 lambs, 76 piglets, 32 ducks, about 300 chickens, and nearly 100 Japanese quails. The 2001 exhibit included a Web cam, provided by the Michigan Farm Bureau, for Internet users interested in witnessing the births of farm animals at the Michigan State Fair. In the first week, the Michigan Farm Bureau Web cam recorded more than 1,000 hits from Internet users. (Both courtesy of the Michigan State Fair.)

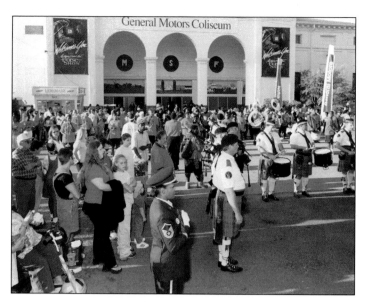

The Michigan Scottish Pipes and Drums band participated in welcoming ceremonies at the 2001 Michigan State Fair. Formed in 1980 under the direction of pipe major William O'Donnell, the Michigan Scottish Pipes and Drums is primarily a teaching band. Notice General Motors had the year's naming rights to the Coliseum. GM also sponsored the Michigan State Fair Horse Show. (Courtesy of the Michigan State Fair.)

As an example of how the state fair clings to roots, homemakers from throughout the state appear to have taken part in the Jell-O Brand NoBake Dessert contest at the 2001 Michigan State Fair. Based on some sashes worn by some of the women, "Homemakers of the Year" from Livingston, Monroe, Oakland, and Newaygo Counties were among those competing. In 1902, the *Ladies' Home Journal* proclaimed Jell-O to be "America's Most Famous Dessert." (Courtesy of the Michigan State Fair.)

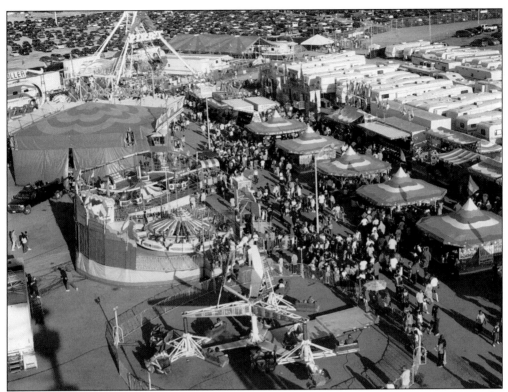

The "Pirat" ride (in the background missing an "e") at the 2001 Michigan State Fair featured a pirate ship that swung back and forth on a pendulum. The carnival ride dates all the way back to the 1890s and is still a midway favorite. Proceeding forward are the Tilt-A-Whirl, Wipeout, and Scrambler, all oldies but goodies. What to choose from? Popcorn, candy apples, corn dogs, Coney dogs, elephant ears, cotton candy, and chocolate nut dip ice cream cones—they all sound good! (Both courtesy of the Michigan State Fair.)

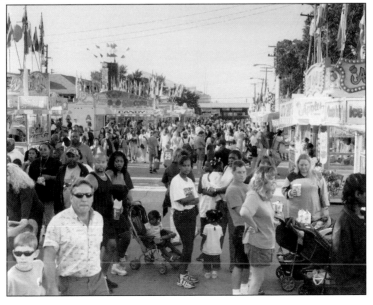

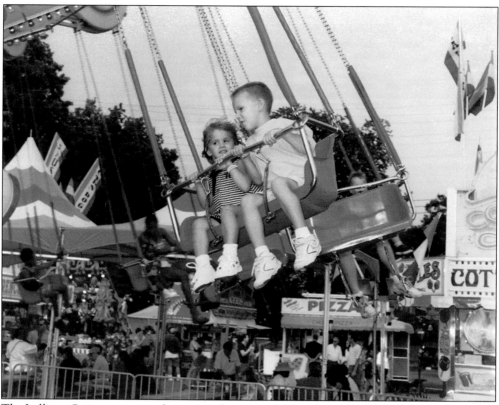

The Lollipop Swings were popular among the many kiddie rides at the 2001 Michigan State Fair. Also known as the Yo-Yo ride, the swings rotated just fast enough to allow centrifugal force to then swing slightly outward. Of course, no fair worth its midway bracelet would be without the ever-popular merry-go-round, or carousel. The latter term also referred to a "horse ballet" that replaced serious jousting during court festivities in mid-16th century, perhaps explaining why horses are mostly used for the ride. The first carousel in the United States was built in the mid-1800s in Hessburg, Ohio. They quickly became a must at all fairs and carnivals. (Both courtesy of the Michigan State Fair.)

This "banana derby" at the 2001 Michigan State Fair was unique. First, instead of riding dogs, the monkeys rode miniature ponies. Second, the monkeys were not real; they were stuffed animals that couldn't get hurt. Note the "World's Largest Stove" in the background. (Courtesy of the Michigan State Fair.)

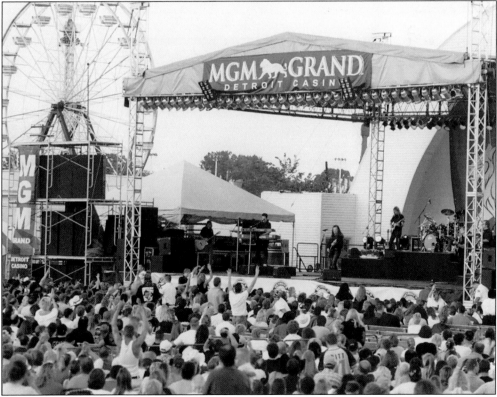

Grammy award–winning American country music artist Travis Tritt performed on the MGM Grand Detroit Casino stage at the 2001 Michigan State Fair. The MGM Grand opened a temporary casino in Detroit in 1999 to great fanfare, and by 2001, the MGM Grand Detroit was very much a part of the Detroit entertainment scene. The temporary stage was set up in front of the Bandshell. (Courtesy of the Michigan State Fair.)

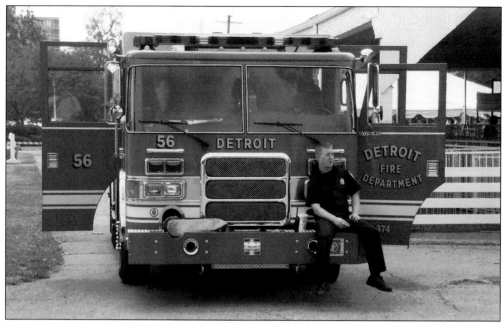

Detroit firefighters, among the "city's finest," were on standby should a mishap occur at the 2003 Michigan State Fair. Perhaps they were taking in the nearby pig races, a favorite among kids and adults. The annual "Pork Chop Downs" at the Michigan State Fair was provided by Sho-Me Swine Racers of East Prairie, Missouri. The porcine races continued to be extremely popular at the Michigan State Fair into its final year of 2009. (Photographs by Jim Bonkowski.)

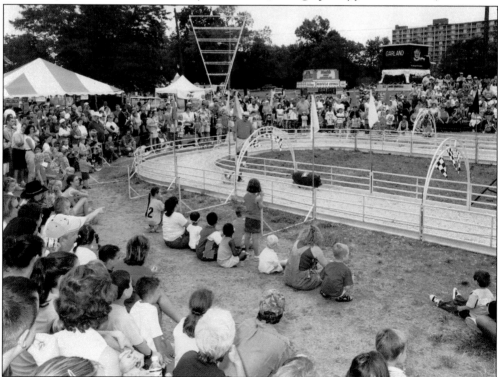

Willie Nelson has played at the Michigan State Fair many times. Here he is performing once again at the 2003 Michigan State Fair. Not only is Nelson a popular country music performer, he is also a gifted songwriter. His compositions include "Night Life" (Ray Price), "Funny How Time Slips Away" (Billy Walker), "Hello Walls" (Faron Young), "Pretty Paper" (Roy Orbison), and most famously "Crazy" (Patsy Cline). (Courtesy of the Michigan State Fair.)

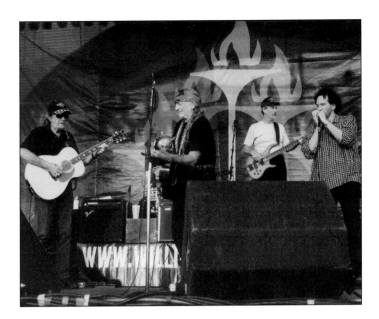

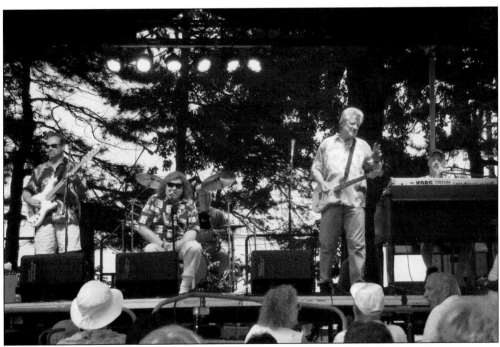

Dean of Jan and Dean performs here in the Family Grove at the 2003 Michigan State Fair. It was not the first time Jan and Dean played at the Michigan State Fair. They performed in Detroit as far back as the 1959 Michigan State Fair. Jan Berry and Dean Torrence were known for their top hits, "Surf City," "The Little Old Lady from Pasadena," and "Dead Man's Curve." Ironically, Jan was nearly killed near Dead Man's Curve two years after the song became a hit and suffered severe brain damage and partial paralysis. That he was even at the 2003 Michigan State Fair was a miracle. He died in 2004. (Photograph by Jim Bonkowski.)

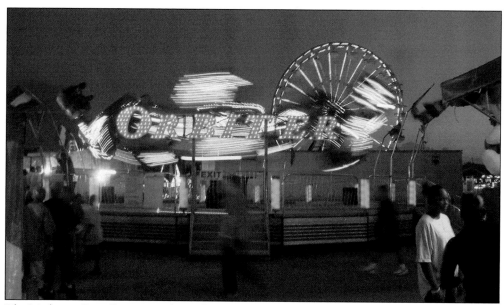

The Michigan State Fair is transformed at night, and the 2005 fair was no exception. The Orbiter was invented in 1976 and consists of six arms attached to a revolving hub. The arms lift 90 degrees, and a cluster of cars is attached to the end of each arm; each cluster in turn spins as well. The carousel at night is a dazzling sight to behold. Children (and adults) ride the wooden horses as they bob up and down, and the whole platform rotates at a comfortable speed. The merry-go-round, or "roundabout" as it is known in England, is truly a ride for all ages. (Both photographs by Jim Bonkowski.)

The petting farm was not just for little ones. Older kids seemed just as thrilled with the animals. Visitors, such as these at the 2006 Michigan State Fair, purchased carrots and other "health" snacks to feed the animals. Clearly this goat knows what is in store. The petting farms also featured exotic animals, such as llamas, Bactrian camels, and Galapagos tortoises, which weigh up to 700 pounds and can live up to 150 years—nearly long enough to have attended all of the Michigan State Fairs. (Photograph by Jim Bonkowski.)

A fixture in the Community Arts Building was the Michigan Floral Association (MFA), shown here at the 2006 Michigan State Fair. The MFA, founded in 1920, is a full-service trade association representing florists, growers, suppliers, wholesalers, educators, and students. The association provides educational and professional partnerships. It also sponsors the Michigan Certified Florist program and conducts educational seminars throughout the year at its Professional Education Center in Haslett, Michigan. (Photograph by Jim Bonkowski.)

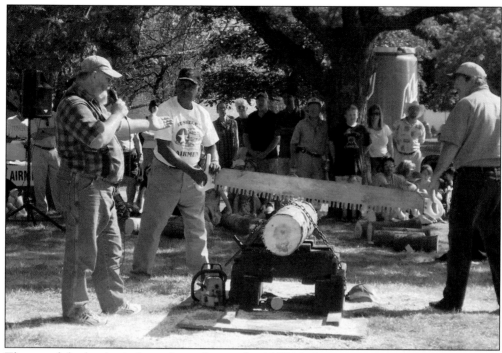

The art of the lumberjack was kept alive at the 2007 Michigan State Fair and into the fair's final year of 2009. Skills on display included crosscut sawing; underhand, standing block, and springboard chopping; axe throwing; chainsaw carving; and log rolling. Taking part in the above demonstration is a Tuskegee Airman. During World War II, the Tuskegee Airmen became the first African American unit in the Army Air Corps, fighting enemies and racism at home and abroad. The airmen and their widows were awarded the Congressional Gold Medal, and the remaining "Red Tails," as they were called, were invited to attend the inauguration of Pres. Barack Obama. (Both photographs by Jim Bonkowski.)

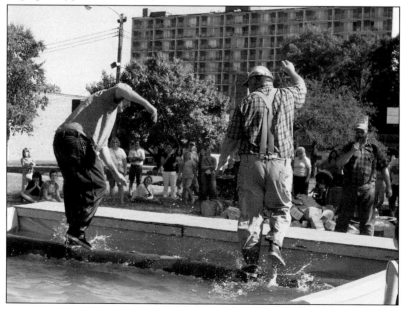

Six

THE PROMOTERS

As director of entertainment and special events, Harold Arnoldi booked all entertainment for the Michigan State Fair for some 40 years. From his office in the Bandshell, he brought in everything from big-name entertainers like Bob Hope to the invitation-only State Fair Honors Band for the best Detroit high school musicians. (Courtesy of Kyle Arnoldi Jolley.)

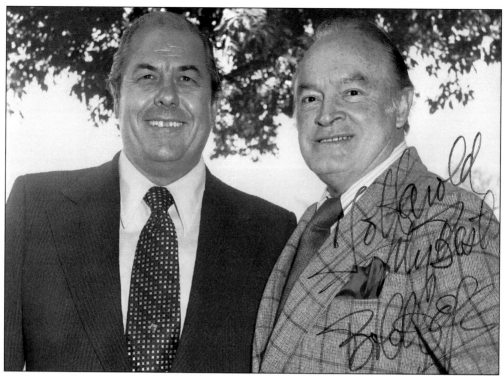

As director of entertainment for the Michigan State Fair, Harold Arnoldi had the opportunity of meeting comedian Bob Hope on at least two occasions: 1971 and 1972, when Hope entertained at the Michigan State Fair. In 1994, Michigan governor John Engler presented Harold and Florence Arnoldi with the Fred Silber Lifetime Achievement Award, recognizing four decades of service to the Michigan State Fair as director of entertainment and special events. Harold was also professor emeritus and director of bands at Wayne State University for 33 years. For 51 years, he arranged pregame and halftime shows as director of entertainment for the Detroit Lions. (Above, Richard F. Lind Photography; both courtesy of Kyle Arnoldi Jolley.)

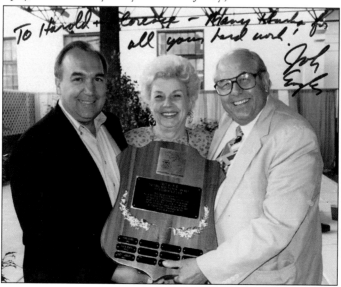

Bob Harris (left), publisher of the *Teen News* in the 1960s, shows Gary Lewis a copy of his weekly newspaper with Jerry Lewis, Gary's father, on the front cover of the July 2, 1966 edition. Gary Lewis and the Playboys had many hits, including "This Diamond Ring," "Count Me In," "She's Just My Style," and "Everybody Loves a Clown." This 1970s photograph was taken outside the entertainer's trailer at the Michigan State Fair. (Photograph by Charles Photography, courtesy of Bob Harris.)

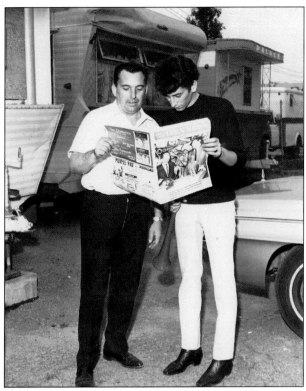

Teen News publisher Bob Harris was able to meet with Bobby Vinton outside the singer's trailer at the 1975 Michigan State Fair. Vinton had 49 top-100 hits, including "Roses Are Red (My Love)," "There! I've Said It Again," and "Mr. Lonely." From 1962 through 1972, Vinton had more *Billboard* no. 1 hits than any other male vocalist. Vinton last appeared at the Michigan State Fair in the 1980s. (Courtesy of Bob Harris.)

At the time of his 1970 and 1972 Michigan State Fair appearances, Charley Pride was at the top of his career and the *Billboard* charts, with 36 no. 1 hits. Pride's dream was to be a professional baseball player, and he may have succeeded if it were not for a stint in the army. *Teen News* publisher Bob Harris cherishes his signed photograph with Pride at the Michigan State Fair. (Photograph by Richard F. Lind, courtesy of Bob Harris.)

By 1972 at the Michigan State Fair, Kenny Rogers and the First Edition had already scored a number of hits, including "Something's Burning" and "Ruby, Don't Take Your Love To Town." For Rogers, though, that was just the beginning. Striking out on his own in 1976, Rogers went on to record 60 top-40 singles including 25 no. 1 hits. *Teen News* publisher Bob Harris spent time with Rogers outside the entertainers' trailers at the Michigan State Fair. (Photograph by Richard F. Lind, courtesy of Bob Harris.)

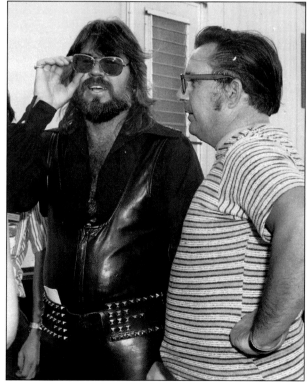

Seven

"MR. STATE FAIR"

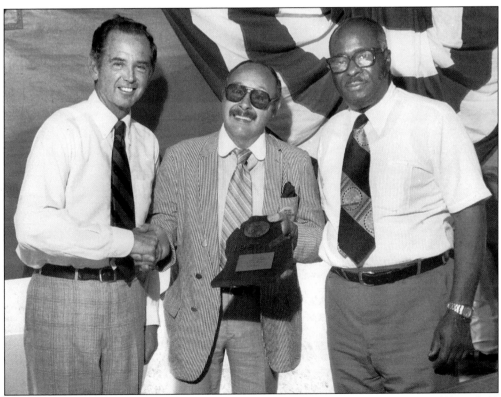

In 1980, "Mr. State Fair" Eugene Kondash (center) was honored by Gov. William Milliken (left) and Secretary of State Richard Austin. Eugene Kondash and his mother, Catherine Kondash, were well known and loved among employees and fairgoers of the Michigan State Fair. Their dedication and commitment to the fair was immeasurable. Eugene said, "It was my life and my mother's life. I gave it 100 percent of my life." (Courtesy of Eugene Kondash.)

In the 1920s, Catherine Kondash's father built this home off of Eight Mile Road in Detroit adjacent to the Michigan State Fairgrounds. Three generations of Kondashes have lived in the home still occupied by Catherine's son Eugene, who is known as "Mr. State Fair." Because of their proximity to the Michigan State Fairgrounds, the Kondashes often invited fair workers to the house for late dinners and counted concession workers and other fair employees as family. After the death of his mother, Eugene deeded the home to the Michigan State Fair. (Photograph by John Minnis.)

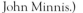

Catherine Kondash displays one of her many first-place floral arrangements. She won more than 100 ribbons over seven decades at the fair. The Catherine Kondash Viewers' Choice Award was created in her honor. Her son Robert would award the youth prize, including a $50 savings bond, while son Eugene would present the award in the adult category. (Courtesy of Eugene Kondash.)

Eugene Kondash poses with chairwoman Millie Machuger after winning first place for a floral arrangement. Kondash not only attended every state fair since his birth, but he also began entering community arts competitions with his floral arrangements at the age of 13. He did so until his appointment to community arts advisor in 1980 and chairman in 1987. (Courtesy of Eugene Kondash.)

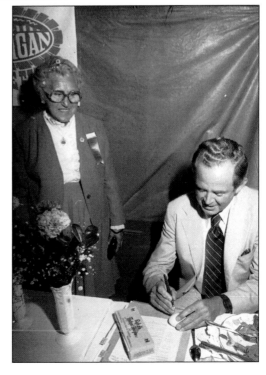

Gov. William Milliken signs an egg for Catherine Kondash at the 1982 Michigan State Fair. It was an annual tradition for her to find an egg in the poultry barn and have the governor sign it. Her collection of eggshells signed by governors goes back to Gov. G. Mennen Williams in 1959. (Courtesy of Eugene Kondash.)

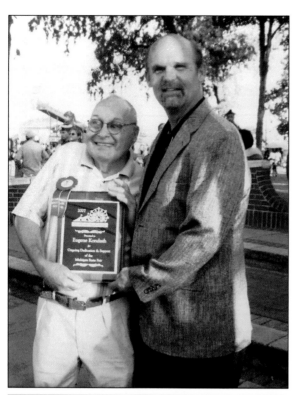

Eugene Kondash and his mother, Catherine, were both honored for their lifelong dedication to the Michigan State Fair. In 2007, Eugene was honored (left) by general manager Steven Jenkins for "ongoing dedication" to the Michigan State Fair. Following Catherine's death in 1992, a memorial was created in her honor, which now sits in the backyard of the Kondash home. It reads, "For her devotion and contributions to the Michigan State and Community Arts." Her son Eugene said that along with winning his first blue ribbon, seeing his mother's name on a plaque was the other highlight of his life with the Michigan State Fair. Book awards, 35 money awards, and the Catherine Kondash Award have been given out in honor of Catherine since her death. Detroit mayor Coleman A. Young called her "one of Detroit's greatest resources." (Both courtesy of Eugene Kondash.)

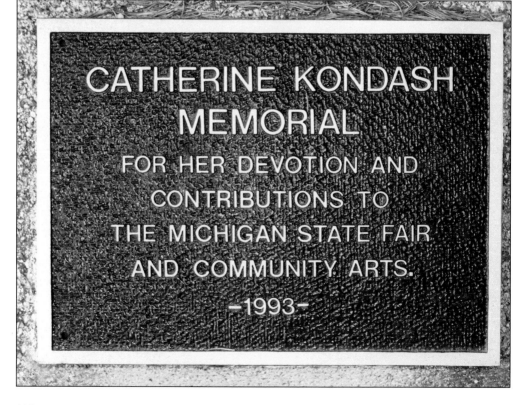

CATHERINE KONDASH MEMORIAL
FOR HER DEVOTION AND CONTRIBUTIONS TO THE MICHIGAN STATE FAIR AND COMMUNITY ARTS.
—1993—

Eight

WORLD'S LARGEST STOVE

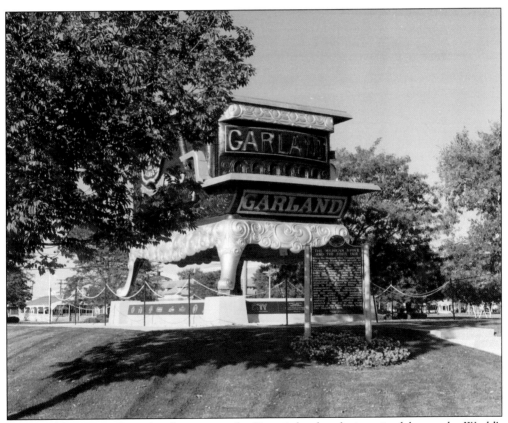

The World's Largest Stove has been a popular Detroit landmark since its debut at the World's Columbian Exposition in 1893. At the time, Detroit's manufacturing industry was booming, and the creation of the world's largest stove seemed to be the perfect way to both celebrate and advertise that. Although it changed locations throughout Detroit several times over its 100-plus years of existence, the massive wooden stove remained a steadfast symbol of Detroit industry. (Courtesy of the Michigan State Fair.)

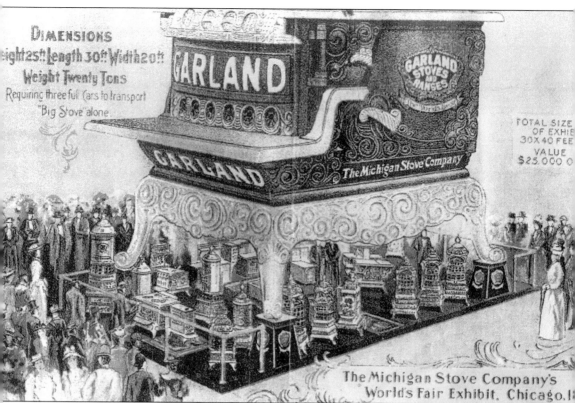

The World's Largest Stove made its debut at the 1893 World's Columbian Exposition in Chicago. Detroit was credited as the "Stove Capital of the World" in the late 1800s and was home to five major stove manufacturing companies. Jeremiah Dwyer, founder of the Michigan Stove Company, built the World's Largest Stove for an exhibit in the Manufacturers and Liberal Arts Building of the exposition. For its design, Michigan Stove Company vice president George H. Barbour sponsored and replicated a "Garland" model kitchen stove built by the company. Pictured is an advertisement and depiction of the stove for its debut in 1893. It would return to Detroit after the exposition and eventually find its permanent home at the Michigan State Fairgrounds. (Courtesy of the Michigan State Fair.)

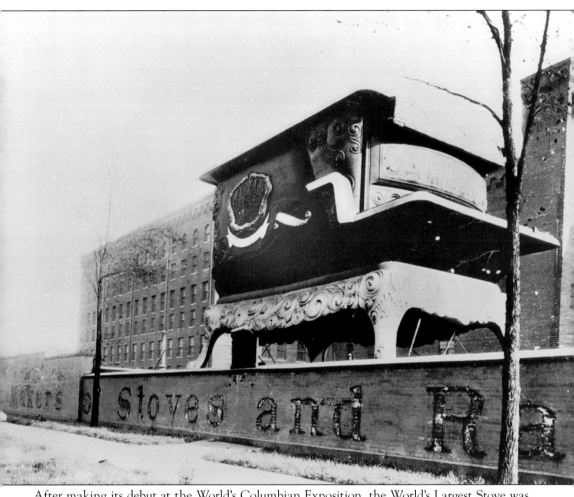

After making its debut at the World's Columbian Exposition, the World's Largest Stove was returned to Detroit and showcased at 3306 East Jefferson Avenue in front of the Michigan Stove Factory. This photograph was taken at the stove's original location in Detroit around 1920. The stove remained at this location until 1927, when it was moved to 6900 East Jefferson, near the Belle Isle bridge. (Courtesy of the Michigan State Fair.)

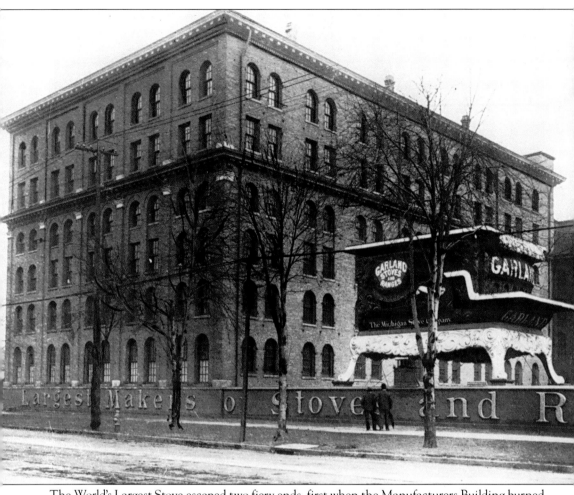

The World's Largest Stove escaped two fiery ends, first when the Manufacturers Building burned down in 1894 and again when the Michigan Stove Factory burned to the ground in 1907. The wooden stove fortunately survived both fires. (Courtesy of the Michigan State Fair.)

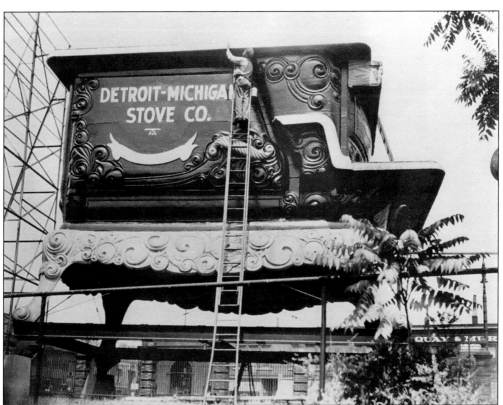

Detroit Stove Works claimed to be "the largest stove plant in the world." This major stove company would become even larger when it merged with the Michigan Stove Company in 1925. The product of their merger was the Detroit-Michigan Stove Company, as is displayed in the above photograph. In 1955, the stove's exterior changed again with the buyout of the Detroit-Michigan Stove Company by Welbilt Corporation. This new name is pictured to the right. The stove remained at its new location of 6900 East Jefferson Avenue from 1927 to 1965, the year the World's Largest Stove moved to the Michigan State Fairgrounds. (Both courtesy of the Michigan State Fair.)

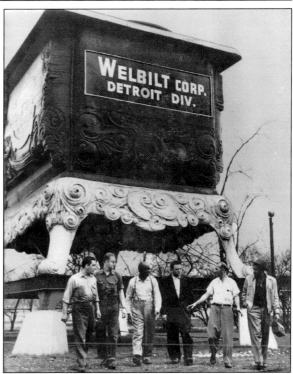

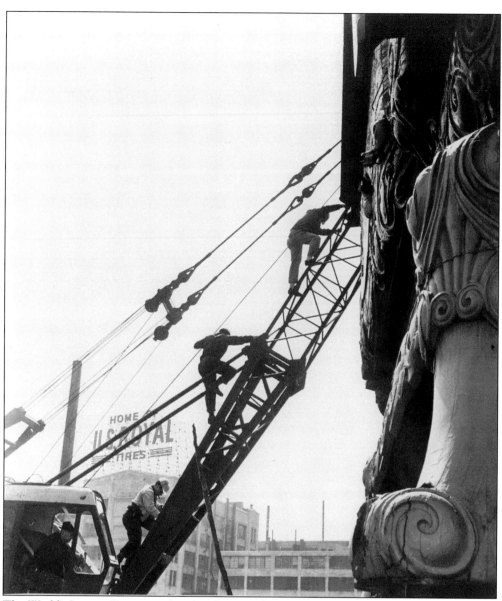

The World's Largest Stove was slated to be moved to the Michigan State Fairgrounds in 1965. This photograph captures riggers preparing the stove for the relocation. It is 25 feet high, 30 feet long, 20 feet wide, and weighs 15 tons. Although the stove was carved out of oak, it was painted to look like metal. The purpose of moving the World's Largest Stove was so it could be an outdoor display at the state fairgrounds, although lack of upkeep would ultimately lead to its deterioration. The "Home of U.S. Royal Tires" in the background was known locally as simply "the Uniroyal plant." It was demolished in the 1980s, opening up 39 acres of prime riverfront property. (Photograph by Andee Seeger, courtesy of Michigan State Fair.)

Mother and daughter watch as the World's Largest Stove is transported to the Michigan State Fairgrounds in Detroit in 1965. At the time, no sponsor or owner's name was displayed on it. As was frequently needed, a new paint job would be completed for its unveiling at the Michigan State Fairgrounds. (Courtesy of the Walter P. Reuther Library, Wayne State University.)

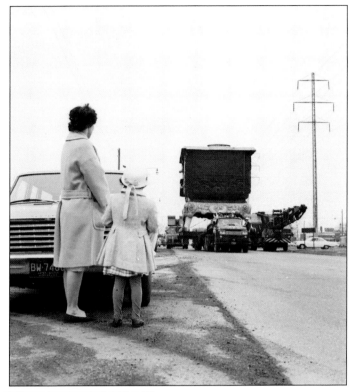

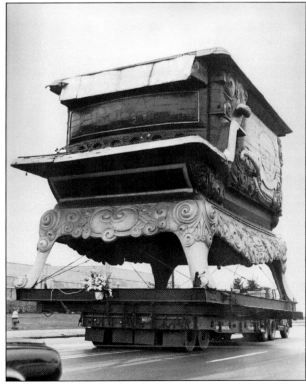

Notice the bouquet of flowers placed in front of the stove for its move—a gift to the Michigan State Fair. Despite its sparkling appearance during its first year at the Michigan State Fair, the stove would only remain on display there for nine years before deterioration forced the structure to be dismantled and placed in storage at Historic Fort Wayne in Detroit. (Photograph by Andee Seeger, courtesy of Michigan State Fair.)

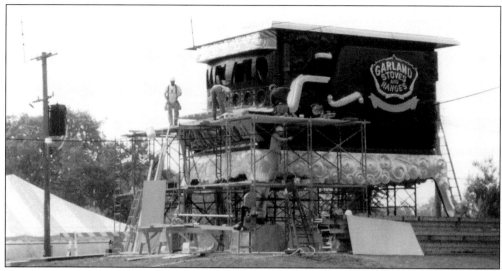

On a rainy day sometime after becoming general manager of the Michigan State Fair in 1993, John Hertel was thumbing through index cards in an old metal box he inherited with the job when he saw a card with the word "stove" on it and a phone number. He called the number—which turned out to be a storage facility at Historic Fort Wayne in Detroit—and learned about the stove for the first time. In 1995, Hertel and 12 trucks went to collect the stored pieces of the stove and found a woodpile of random pieces. He launched a fund-raising campaign in 1998 for the $300,000 needed to restore the World's Largest Stove. Builders had to reconstruct the old stove without original blueprints. (Courtesy of the Michigan State Fair.)

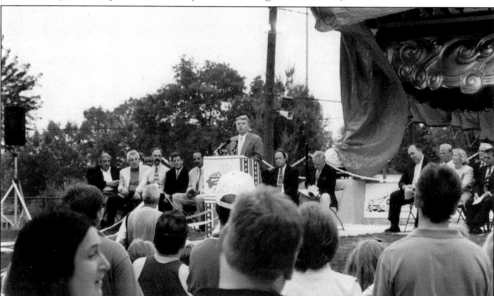

After 24 years in storage, months of raising funds, and hours of workmen's labor, the newly restored World's Largest Stove was unveiled on August 24, 1998, by Michigan State Fair general manager John Hertel. The year was also important in that it marked the 150th anniversary of the Michigan State Fair. Countless individuals, donors, media, and organizations, including the Detroit Historical Society and WJR Radio, made the restoration possible. Note how dwarfed Hertel is by the stove. (Courtesy of the Michigan State Fair.)

Nine

THE LAST
MICHIGAN STATE FAIR?

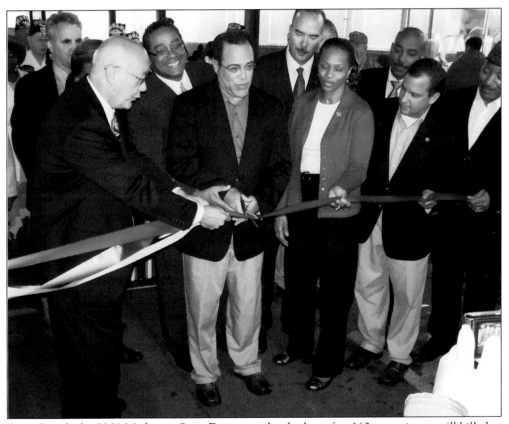

Even though the 2009 Michigan State Fair was to be the last after 160 years, it was still billed as "Bigger, Better and the Best Fair Ever!" Seen at the ribbon-cutting ceremony are, from left to right, state fair general manager Robert Porter, Wayne County sheriff Benny Napolean, Wayne County executive Robert A. Ficano, Oakland County deputy executive Phil Bertolini (representing L. Brooks Patterson), Darchelle Strickland-Love (representing Detroit mayor Dave Bing), community leader Dr. Jimmy Womack, Macomb County chairman Paul Gieleghem, and Detroit councilman Kwame Kenyatta. (Photograph by John Minnis.)

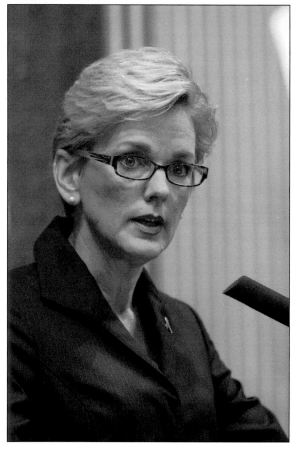

Due in part to the recurring recession at the start of the 21st century and the decline and bankruptcy of the U.S. auto industry, Michigan governor Jennifer Granholm faced a $1.8 million budget deficit. In a cost-cutting move, on February 12, 2009, a Granholm executive order cut funding for future state fairs, effective October 31, 2009. Subsequently, Granholm vetoed a $7 million line item that would have added one more year to the Michigan State Fair. As of December 2009, the Michigan State Fair was no more. (Above, photograph by John Minnis; at left, courtesy of Gary Shrewsbury.)

General Motors was the only Detroit automaker with a pavilion at the 2009 Michigan State Fair. By that time, GM had already filed and emerged from bankruptcy. Gone were Pontiac and Saturn. The new General Motors would focus primarily on its four core brands—Chevrolet, Cadillac, Buick, and GMC. Surprisingly absent from the 2009 fair was Ford Motor Company, the only Detroit carmaker to avoid bankruptcy. However, Ford products were present at the fair in the line of Model As taking part in the opening-day, rain-shortened parade. The Model A below bears a 1931 license plate and the emblem of the Model A Restorers Club. (Both photographs by John Minnis.)

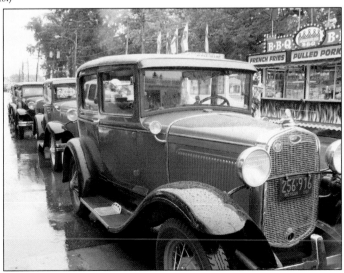

The Supreme Champion Draft Halter Horse competition on Labor Day at the 2009 Michigan State Fair was an elegant occasion. The horses and their owners were really stepping out to send off the last Michigan State Fair in style. The Coliseum has borne many names during its 85 years, but the last name it will bear is that of Hertel, after John Hertel, who served as the fair's general manager from 1993 to 2006. During that time, Hertel was also chairman of the Macomb County Board of Commissioners. Hertel raises Percheron horses on his farm in Lenox Township, Michigan, and has won three national championships with his horses, which he has exported to France, Mexico, and Canada. (Both photographs by John Minnis.)

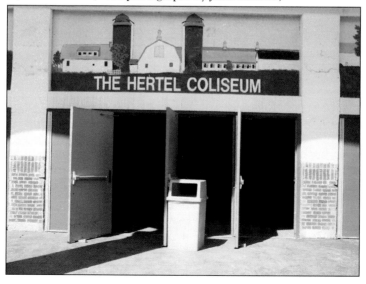

The 2009 Michigan Butter Cow, Juno, and her calf, Leeper, were carved out of 330 pounds of unsalted butter by Tom Paul Fitzgerald of Almont, Michigan. Fitzgerald has been doing this since 1989, when he took over for Frank Dutt, who retired after sculpting some 40 butter cows over the years. (At the 1950 Michigan State Fair, a butter sculpture of a cow and farmer by J. E. Wallace required 450 pounds of butter.) The sculptures were funded by United Dairy Industry of Michigan in order to promote the dairy industry in Michigan. (Photograph by Don Bishop.)

"Daisy," the Michigan Milk Producers Association's (MMPA) huge, fiberglass Holstein cow, stationed outside the Michigan Mart and Miracle of Life Buildings on Great Lakes Boulevard, was the symbolic source of the butter used to make Juno and Leeper, the butter cow and calf. The butter was churned at the MMPA's dairy plant in Constantine, Michigan. With the 2009 Michigan State Fair being the last, Daisy will most likely be put out to pasture. (Photograph by John Minnis.)

A fairgoer tries her hand at milking a cow at the 2009 Michigan State Fair. She found out it is not as easy at it looks. Visitors to the dairy barn also got to purchase a bottomless cup of "fresh-squeezed" milk for 50¢. The bunnies in the Poultry and Rabbit Building were always a favorite for children, including this little girl at the 2009 Michigan State Fair. On exhibit were all manner of rabbits, chickens, turkeys, pigeons, ducks, and geese. One wonders what will happen to the beautiful Poultry and Rabbit Building, which deserves its place on Michigan and national historical registries. (Both photographs by John Minnis)

An old fire truck at the 2009 Michigan State Fair served as an advertising medium for ICARE II, an organization dedicated to the preservation of the fairgrounds at Woodward Avenue and Eight Mile Road in Detroit. ICARE (Inter-county Citizens Achieving Regional Excellence) was formed in 1996 to combat proposed auto racing at the fairgrounds. The group has since changed its name to ICARE II and favors an Agriculture Industries Science Institute be established on the fairgrounds to take advantage of the existing buildings and remain true to J. L. Hudson's original intent when he donated the land to Michigan State Agricultural Society back in 1905. (Photograph by John Minnis.)

Members of ICARE II collected some 50,000 signatures at the 2009 Michigan State Fair in an effort to convince state lawmakers and Gov. Jennifer Granholm to fund future fairs. The petitioners were initially successful in that the legislature did earmark $7 million for a 2010 Michigan State Fair. However, Governor Granholm vetoed the allotment. As of December 2009, the 160-year-old Michigan State Fair is a thing of the past. (Photograph by Don Bishop.)

DISCOVER THOUSANDS OF LOCAL HISTORY BOOKS FEATURING MILLIONS OF VINTAGE IMAGES

Arcadia Publishing, the leading local history publisher in the United States, is committed to making history accessible and meaningful through publishing books that celebrate and preserve the heritage of America's people and places.

Find more books like this at
www.arcadiapublishing.com

Search for your hometown history, your old stomping grounds, and even your favorite sports team.